Praise for *Smudge Lies and Letting God Write Your Story*

"Aimee Fuhrman's message and ministry are needed in our world of carefully curated perfection. Her story of brokenness and surrender reflects the awesome glory of a God who transforms lives. *Smudged Pages: Letting Go of the Lies and Letting God Write Your Story* contains truth every person needs to know."

-Kary Oberbrunner, CEO of Igniting Souls, author of *Unhackable, Day Job to Dream Job,* and *Elixir Project*

"*Smudged Pages: Letting Go of the Lies and Letting God Write Your Story* spoke to my heart. It was like Aimee was inside *my* head and understood the lies *I* struggle with. Her stories of overcoming and the truth she shares from God's Word give hope."

-Amber Johnston, HeritageMom.com, @heritagemomblog

"Aimee's honesty is a breath of fresh air! By peeling back the layers of her life, she helps us see that we don't have to have it all together, we just need to be surrendered to the Author of Life."

-Tiffany Thenor, Co-Owner/Co-Founder of WonderHere @raising.wonders, @wonderhere

"Aimee's heart for women comes through on every page! I appreciate that she doesn't sugar coat the struggles of life or the doubts we have about ourselves and God. Instead, she shows that it's okay to be imperfect—God's got a plan to use us just the way we are"

—Emily Grabatin, author of *Dare to Decide: Discovering Peace, Clarity and Courage at Life's Crossroads*

"Aimee Fuhrman delves so deep! If you want to break free from the lies the enemy has been feeding you, this powerful book is the one to read! I highly recommend it."

-Faye Bryant, author of the *Grandma, Mom, and Me Saga*, motivational speaker, certified Unhackable Life and Purpose coach and trainer

"So many of us fight mental battles. We struggle with lies about who we are and what we can or cannot do. Aimee's book *Smudged Pages: Letting Go of the Lies and Letting God Write Your Story* helps readers identify those lies and gives some tools to overcome them. I highly recommend it!"

-Kristin Reiss, mother of four, foster mother, and youth worker

Smudged Pages

Letting Go of the Lies and Letting God Write Your Story

Also by Aimee Fuhrman

The Smudged Pages Companion:
A Guide to Letting Go of the Lies

The Smudged Pages Devotional:
Replacing the Lies with God's Truth

Reclamation

Replication

100 Books to Learn to Read

Wonderful Writing Prompts

Stupendous Story Starters

Smudged Pages

Letting Go of the Lies and Letting God Write Your Story

AIMEE FUHRMAN

AUTHOR ACADEMY elite

SMUDGED PAGES: LETTING GO OF THE LIES AND LETTING GOD
WRITE YOUR STORY

Copyright © 2020 by Aimee Fuhrman.
Cover design by Heidi Fuhrman.
Printed in the United States of America.
Author Academy Elite
P.O. Box 43 Powell, OH 43065.
www.AuthorAcademyElite.com

Library of Congress Control Number: 2020920107
ISBN
Paperback: 978-1-64746-566-7
Hardback: 978-1-64746-567-4
E-book: 978-1-64746-568-1

All scripture quotations unless otherwise indicated are taken from The Holy Bible, New International Version®, NIV®. Copyright © 1973, 1978, 1984 by Biblica, Inc.™. Used by permission of Zondervan Publishing House. All rights reserved worldwide.

Scriptures marked ESV are from the ESV® Bible (The Holy Bible, English Standard Version®), copyright © 2001 by Crossway, a publishing ministry of Good News Publishers. Used by permission. All rights reserved.

Scriptures marked NCV are from the New Century Version®. Copyright © 2005 by Thomas Nelson. Used by permission. All rights reserved.

Scriptures marked NET are from the New English Translation, NET Bible® copyright ©1996, 2019 by Biblical Studies Press, L.L.C. http://netbible.com. Scripture quoted by permission. All rights reserved.

Italics added to Scripture quotations are the author's emphasis.

Some names and identifying details have been changed to protect the privacy of individuals mentioned in this book.

This book is dedicated to my husband—
who has loved me through all the lies.

It is written for all who believe
their story is no good because of
the smudges on their pages.
Be encouraged—
the Author of your story is
writing a Masterpiece.
He will not quit until it is finished!

With Special Thanks

The following people showed their faith in *Smudged Pages* by investing in this project when it was only a dream. This book wouldn't be possible without them:

- James Beeson
- Susan Cecil
- Heidi Fuhrman
- Roger & Linda Fuhrman
- Ryan Fuhrman
- Janet Elliot
- Jen Harrington
- Meredith Hooker
- Karol Ann Krakauer
- Giny McConathy
- Dave & Elizabeth Marshall
- Lestel Meade
- Steve Parker
- Teddi Parker
- Jason & Leah Rohlf
- Monica Sheppard
- Toby Sheppard
- Jeff & Angie Shoemaker
- Monique Thompson
- Jacob Troyer
- James Wade
- Frances Way
- Janet Zuniga

In addition, I would like to thank the following people for giving valuable feedback during the editing phase:

- Amy Fisher
- Joel Gilbert
- Kristin Reiss
- Rose Saldarriaga

Table of Contents

A Note to the Reader

Before I get started, I'd like to say that just because I've written this book doesn't mean I have it all together. Believe me, I don't. I haven't somehow magically "arrived." Like you, I'm still walking this journey.

The reality is none of us arrive this side of Heaven. We live in a broken world and struggle with what the Bible calls our flesh. We take two steps forward and one step back. Sometimes it's worse. We trudge up a daunting hill and stand for one minute at the top feeling relieved and successful, only to slide back down and have to start all over.

I wish it wasn't like this. I wish I could say, "Read this book and you'll find the magic formula which will transform your life." But that's not the case. I too have struggled and failed. I still struggle; I still battle with lies. It's part of the curse which will one day be lifted when Jesus returns and restores this broken world. Over the years, though, I have found some measure of success. In this book I share with you the lessons I've learned along the way.

I hope you find comfort in these stories, in knowing someone else has trudged up that same hill. And if you should see me sliding back down on your way up, reach out a hand and catch me, won't you? After all, we're in this together.

Blessings,

Aimee

The Story's Premise

(An Introduction)

God intends for my life to be a Masterpiece written by him, but too often I snatch the pen from his hand and write a destructive counterplot.

I love stories. I always have. As a very young child of two or three, my parents would tuck me into bed only to hear me minutes later retelling myself the bedtime story they had just finished reading to me. My love for stories only intensified once I could read them for myself, and I often had my nose in a book, even while walking home from school!

Not only do I love to read stories (or watch them—I'm a big movie fan), I also like to write them. My writing "career" began early. I composed my first poem in kindergarten for the sheer joy of the word picture and the rhyme. At age seven, I wrote a short story about Strawberry Shortcake which I sent off to the Kenner toy company with dreams they would make it into a picture book. They wrote back saying they couldn't

publish my book, but they did send me a lot of swag and the latest character doll. When I got older, I joined the writing club at my junior high and started several novels (though none were ever finished). In high school, I found a renewed fervor for writing poetry, and in college I journaled. More recently, I've found a passion for writing young adult novels and children's picture books. Like I said, I love stories.

Perhaps you enjoy stories too. If so, you're in good company. Almost all of humanity loves a thrilling or heartwarming tale. From the revered bards of bygone eras spinning their epic accounts of heroes to modern blockbuster movies at the box office, stories hold a place in our culture and in our hearts. What is it about stories we find so captivating? Why do Americans spend tens of thousands of dollars each year to watch, read, and listen to stories? I believe we see ourselves reflected in every one of them.

Oh sure, I may not *fully* identify with Bruce Banner morphing into a big green monster. After all, I'm neither a man nor a scientist and certainly not a superhero! But I identify with his struggle to maintain control. I identify with the fear and frustration he feels. I too have parts of my soul I'd rather not let the world see.

So it is with every story. I can identify with some character, some event, some emotion in every tale I take in. This feeling of familiarity is sometimes comforting and sometimes unsettling, sometimes inspirational and sometimes challenging, but never unusual. Why? Because we were *designed* for story. Our very lives are stories being written by a Master Author. Or at least they should be. But sometimes we take the pen out of his hand and try to write the story ourselves.

> *Our very lives are stories being written by a Master Author.*

As an author, I hate it when my characters do this. Sometimes I'll be writing along and the plot will veer off

course. One of the characters says or does something I wasn't expecting. "What are you doing?" I want to yell. "You're derailing the plot!" You might be wondering how this can happen if I'm the one writing the story.

"Don't you have complete control over what the characters say and do?"

The answer is no, not always. If you're not an author I can't fully explain this except to say my characters have autonomy. They do what they will. Sometimes I can work with where they're headed. Sometimes I can get them back on track. And sometimes they just trash the story.

We too have autonomy. God's given each of us a free will. If we dare to snatch the pen out of his hand and start writing, he lets us. The trouble is we really don't know how to write our own stories. Sure, we know the characters (we are obviously the main characters, while our loved ones and acquaintances play lesser roles), and we know the setting (the time, place, and circumstances into which we are born and continue to live). We even have an inkling of how it's supposed to turn out (God wants each of us in his kingdom), but we don't *really* know the storyline. My writing my own real-life story is like my seven-year-old self trying to write something worthy of publication for a phenomenally popular brand of a successful toy company.

So why do we do it? Why do we grab the pen out of our Author's hand and scribble nonsense when he knows exactly what he wants to say through our lives? I think it's primarily because of our story's Antagonist—that ancient deceiver whose goal is to steal, kill, and destroy.

Every story has an antagonist, the primary one who opposes the main character and impedes his or her progress. Satan is the Antagonist of our stories. His fierce hatred for our loving Father and our Savior translates into malice for us. His primary goal is to derail the plot and ruin the theme of God's mercy and faithfulness in each and every life's story. If he can

get us to believe his lies then he can get us to derail our own stories, much like my characters who have no clue where I, the author, intend for them to go.

Sadly, more often than not we believe him. We snatch the pen away from our loving Author who writes only what is for our greatest good, and we write furiously the script to our Antagonist's counter plot. We do it because we think we'll achieve the happy ending we want. But in reality that counter plot is at best a dead end and at worst the most tragic ending ever written.

My whole purpose for writing this book is to help you discover the lies leading you down dead-end plotlines. I've organized this book into sections. Each section covers one broad category of lies I've struggled with. Within each section you'll find bite-sized readings detailing a specific lie. I've tried to explain and illustrate each lie with a story from my own life and have included scriptures to counter the lie. I hope these stories resonate with you. Perhaps you'll see yourself in them.

Consistently when I share my life's story with others I hear, "Thank you so much for being vulnerable and sharing your story; I thought I was the only one." When we are languishing in the destructive grip of the Antagonist's lies, we often feel alone. But know this, friend, you are *not* alone. I've been there; others have too. The apostle Paul exhorted the early Christians in Corinth with words which still ring true today:

No trial has overtaken you that is not faced by others. And God is faithful: he will not let you be tried beyond what you are able to bear, but with the trial will also provide a way out so that you may be able to endure it.

1 Corinthians 10:13, NET

God's truth is our way out. When the Holy Spirit speaks truth into our hearts and minds, it brings freedom, peace, and joy.

My life's circumstances have shaped me, every last one of them. Some have made me stronger, but some have torn me down and made me susceptible to the lies of the Antagonist. The times I have believed those lies are the times I've stopped trusting the Author, have stolen the pen from him, and have tried to write the story myself.

In the same way, your circumstances—both good and bad—have shaped you. They've shaped your personality, your strengths, and your weaknesses. And whether you realize it or not, your life's circumstances have created mental blind spots—places where the insidious lies of the Antagonist can seep in. The lies addressed in this book are things I've struggled with personally. This is not an exhaustive list by any means. What you struggle with may be different from what I battle. But maybe you'll see yourself in these pages. I hope you'll find solace knowing someone else has shared similar struggles, as well as the motivation to begin confronting those lies and combating them with the truth. Life is too short to wander down dead-end counter plots, not to mention the frustration and angst in trying to write such a story.

Are you there, friend? Are you squeezing the pen tightly while your fingers cramp and your head hurts, trying to decipher what the next chapter should be? If so, come along with me as I reveal some of the lies of the Antagonist. I pray you'll find the courage to hand the pen back to the Author so he can write the Masterpiece he wants your life's story to be.

The Story's Theme

(Thinking about Identity and Lies)

My identity and the lies I believe are inter-
twined. I must replace the lies with God's
truth to find my true identity.

I never dreamed as a young girl my story would include an almost suicide attempt. I was a confident girl from a loving home; little about my life spelled crisis. Yet, not too many years ago I found myself depressed and ready to end it all. How did I go from feeling loved and successful to feeling alone and like a failure? Lies.

The Antagonist—Satan, the enemy of all humanity—slowly wove his lies into the fabric of my life until they were so integrated they seemed like the theme of the story. When I looked at the pages of my life, all I saw were smudges and rips. I couldn't fathom how my life could be the masterpiece I knew God originally intended when I had sullied the pages

so. Instead of his message of love, I was sure my story's theme was one of failure.

Every story has an overarching theme. It's what the story is about—the *essence* of the story. Our lives are no different. Your identity in Christ and his purpose for you is the theme of *your* story, just as my identity and purpose are the theme of mine.

The Merriam-Webster Dictionary describes identity as "the distinguishing character or personality of an individual." It is who we *are*. Our identity is comprised of all the elements which define us—race, gender, age, occupation, and a myriad of other things. If you are a Christian, your first and primary defining factor is child of God. Actually, it should be *the* defining factor—the singular truth informing all other facets of your identity.

But so often we let other elements take center stage. When we do, we open our minds to the influence of conflicting and negative voices which seek to redefine us. Our identity becomes, in our minds, something less (or more) than what we really are in God's eyes.

The study of personal identity and the mind-soul connection falls under the science of philosophy. Christine Serva, an educator and writer, in her online introductory philosophy class describes personal identity as "the concept you develop about yourself that evolves over the course of your life."[i] This definition differs slightly from the dictionary definition above; it puts our identity solidly inside our own minds. So which is it? Is it who we *actually* are or who we *think* we are?

From God's perspective, our identity is solidly rooted in our relationship with him. Anyone who has accepted his free gift of grace is clothed in the robe of righteousness Jesus' death bought for us and which we wear by our faith in him. If you are a believer, your identity is defined as child of God. Love, mercy, transformation—*this* is the theme of the story God is writing in your life. And his outline for your story is

all about his grace in you and your reflection of his grace to the world around you.

But most of us don't live in this reality. We struggle with our identity in our own minds, defining ourselves by any number of other factors. Relationships, experiences, successes, and failures all play into our beliefs about ourselves, which in turn translate into thoughts, decisions, and actions. As Christians we live with one foot in Heaven and one in the here and now. Our identities are a jumble of both who we are in Christ and all the temporal factors by which we identify ourselves. It's part of living in this broken world.

The problem comes when we begin to *define* ourselves by these other factors. This is exactly what the Antagonist wants. He speaks so many lies into our hearts and minds in an effort to get us to buy into *his* message instead of the true message of our Author. Scripture tells us Satan is the father of lies; lying is his native language *(Jn. 8:44)*. He slithers up beside us and whispers poison into our minds—lies which form the basis for a counter plot to our stories.

This book is a revealing of many of those lies. These are lies I've heard and believed myself. Some of them will be familiar to you; you've heard them mercilessly whispered to you as well. There are hundreds of other lies and thousands of variations, but my hope is that this will be a starting place and will open your eyes to some of the lies you've believed. Awareness is half the battle. When you know what you're up against, you can begin to fight it.

Honesty is also key. Admitting you've bought into a lie is humbling, but it is the first little step toward freedom. This isn't easy to do. Often it is painful. It requires being real with yourself and confronting insecurities which may have been plaguing you for many years. Don't be afraid to look them in the face and call them by name. You can't edit the story until you know which words to delete.

Once you can identify a lie, take some time to realize how it's been impacting you. This may be painful, but take a candid look at your life. You may even need to own up to some sin like I did.

"Wait a minute!" you might say. *"I was deceived. I didn't even realize I was living a lie!"*

True, you have been a victim. But playing the victim's card will not get you any closer to freedom. I know in my own life there were some lies I clung to even once they'd been exposed. I used them as crutches. In doing so, I participated in the enemy's agenda. In addition, some of the outcomes of the lies I believed (even the ones I was unaware of) resulted in indiscretions and even abuses on my part. If this is the case for you, own up to your sin regarding the lies you've bought into. Take the time to admit your own shortcomings and failures in these areas. Ask God for forgiveness—He promises it! Ask yourself for forgiveness—and give it. Ask others for forgiveness too if needed.

> *Ultimately, you have to replace the lie with truth—God's truth.*

Ultimately, you have to replace the lie with truth—God's truth. It's time to turn over the pen and let the Holy Spirit begin doing the work of editing your story. My goal in telling *my* story is not to give you answers and solutions. The reality is, I don't have any answers in and of myself, which is why this book does not contain a three- or five- or seven-step process to getting free of the lies. Only God can set you free. Instead, I've included Scripture at the end of each reading—a countermeasure of God's truth straight from his Word. Jesus said,

> *"If you abide in my word, you are truly my disciples, and you will know the truth and the truth will set you free."*
>
> *John 8: 31b-32*

Scripture is our God-given weapon to defeat the enemy *(Eph. 6:17)*. Jesus modeled this for us during his testing by the devil after his forty-day fast in the wilderness *(Mt. 4:1-11, Lk. 4:1-13)*. With Scripture we renew our minds and realign our thinking with God's outline for our story. I encourage you to take the time to do this. Read the verses, meditate on them, memorize them if you need to, and use them whenever the lies seek to undermine your identity. Do this again and again if necessary.* Whenever Satan tries to sneak them back into your story, stand in faith and in the power given to you as a child of God! And press into the Holy Spirit. He's the one who can help you renew your mind and release your grasp on that pen.

All of this may sound exhausting and make you wonder if it's worth it. But this process, like writing a story—a good one anyway—is hard work. It takes time and dedication and a lot of rewriting. Roald Dahl, beloved children's author of such books as *Charlie and the Chocolate Factory*, once said that by the time he neared the completion of a story, portions of it had been reworked at least a hundred and fifty times! The good news is *you* are not the author. The Holy Spirit is there to do the heavy lifting; you just have to cooperate in the process!

* If you'd like more help in walking through this process, I recommend getting *The Smudged Pages Companion: A Guide to Letting Go of the Lies*.

Truth from God's Word

God has given us power to defeat the Enemy both in our minds and our hearts. Take some time to read and meditate on these Scriptures:

- ❖ Psalms 108:13
- ❖ Proverbs 4:18-19
- ❖ Proverbs 14:8
- ❖ John 8:31-32
- ❖ John 8:43-44
- ❖ Romans 12:1-2
- ❖ 2 Corinthians 10:3-5
- ❖ 2 Timothy 3:16-17
- ❖ Hebrews 4:12-13

The Story's Setting

(Factors that Contribute to Believing Lies about Identity)

The station into which I am born—location, time in history, and circumstances—shapes my identity.

I've always joked I was born in the wrong decade. In my idyllic world, I'd belong to my parents' or grandparents' generation. Oh, to have been born in the 1930's when childhood was a simple matter full of hopscotch and grammar school, evening radio programs and dime store candy. To come into the prime of life when patriotism swelled in each noble breast and young men looked sharp in uniforms, when newsreels played before the Friday night picture show and Big Band swing was the sound of the era. Or to have been born during the 1940's and have a childhood filled with *The Lone Ranger* and *The Mickey Mouse Club* on television and Dick and Jane in the classroom. When jump ropes and jacks were the norm after school, and comic books were sold for a quarter.

To spend the teen years with poodle skirts in the closet and Elvis Presley in the jukebox.

'Sigh.' It sounds so wonderful and simple. These were the decades where enough medical knowledge and technological advances existed to make life comfortable and relatively pain free without all the frenetic striving of our high speed global age. Yes, I know all about the bread lines and the foreclosures of the Great Depression, the heart wrenching partings with brothers and sons and lovers who never returned during World War II, the suspicion and distrust of the McCarthy Era. But all those difficulties seem tame in comparison to mass shootings, human trafficking, terrorism, global pandemics, and even the incessant demoralizing of our staged and upstaged online existence.

I know I'm not alone. There's a reason why "the good old days" is a phrase in our society. Many of us look longingly over the fence of time and see the greener pastures of a bygone era. But we haven't been given that lot. We've been put in *this* time and *this* place. The Bible tells us,

> *God began by making one person, and from him came all the different people who live everywhere in the world. God decided exactly when and where they must live.*
>
> *Acts 17:26, NCV*

The time, the place, and the circumstances into which we are born are the setting for each of our life stories. We don't get to choose them. They are determined by the Author.

Whenever I write a story, the setting plays a huge role in what kind of story it is. My world building looks very different for my young adult dystopian novels than it does for my historical picture books. Before I can even begin to envision how my characters are going to act and think and speak, before I can set the plot in motion, I've got to have a

setting. The story has to occur *somewhere* in time and space. The same is true for our lives. My life's story is going to look very different from that of a girl growing up in South Bronx, and *her* life is worlds apart from a girl living in Saudi Arabia. Who we are and who we are likely to become is determined largely by the setting into which we're dropped.

We can fight this. We can, like I am prone to do, pine for a different time and place. We can even resent our lot in life—our family dynamics, our socioeconomic station, even our gender or race—but the Author has placed each of us in our unique settings with a purpose and an outcome in mind.

Pride and Prejudice wouldn't be the same story set in the 1990's. If *The Tale of Two Cities* had been set in Russia during the bourgeoisie revolution it would, to be sure, share some similarities with its current form, but it would still be a different tale. And *The Grapes of Wrath* would not even exist without all the hardship and struggle, since pain is the very essence of that novel.

The same goes for your life and mine. As the main character of my story, I tend to fight against every difficulty that comes my way. But without the struggles, my story would not be my story, and it would, quite frankly, fall flat. We *need* pain; we *need* hardship (at least a little) for the story to be worth reading.

Still, pain and hardship often open the door to believing lies about our identity. Self-preservation is inherent to our human nature, so when trials come we'll do just about anything to stop the pain. It's one thing to quote,

The LORD is my strength and my shield; in him my heart trusts, and I am helped.

Psalms 28:7, ESV

It's quite another to believe it or even put it into practice.

15

This is when the Antagonist of the story likes to step in and convince us that trust and surrender to the Author is not in our best interest. Instead, he supplants the truth with all kinds of lies about ourselves, others, and even God. A child who experiences pain from her father, for example, is far more likely to distrust men in general. She may even have a hard time seeing God as a loving father. Why? Because the Antagonist takes advantage of something in her life's setting to convince her of the lie that all men are cruel and cannot be trusted.

Sometimes the lies creep in despite an almost idyllic setting. Such was true for me. I was born into middle-class America with no real unmet needs and few unmet wants. My family was incredibly loving and supportive, offering a stable setting in which to grow and flourish. I was raised in a Christian environment and embraced the faith at an early age. One would think all this would ensure a healthy self-image.

But somewhere along the way I assumed the notion that I needed to be perfect (or at least nearly perfect). My acceptance of myself hinged on this, so I developed habits I believed made me strong. What seemed like strength to me, however, was really a weakness which made me susceptible to a whole slew of the Antagonist's lies.

Anything can be fodder for our enemy, but he seems to frequently use relationships, performance, and disappointments as springboards for his lies. And once we've bought into one lie, it is easier to believe other similar lies about ourselves or others. It's a kind of awful compounding interest of the soul.

And once we've bought into one lie, it is easier to believe other similar lies…

Once in this trap it is easy to assume our value is lost. How could God want us or use us when our pages are so torn and dirty? But a torn cover and dog-eared pages don't have to mean trash. They can mean well-loved.

When it comes to my story, I like to think of these imperfections as smudges on my pages. The pain, the struggles, the weaknesses and failures are like coffee rings and Kool Aid stains, grease splotches and Cheetos fingerprints. I have the tendency to look at my smudges and see a mess. But the Author sees pages still worth writing on. And when I think surely no one would want to read my story because of all the stains, others look at the messy pages of my life and breathe a sigh of relief—because their pages have smudges too.

It takes courage to face our life's setting with honesty, to look at the various elements of our lives and figure out where the lies have crept in. It can be even harder to address the lies once we know they are there. But hope, as we will see later on, is the tone of every story God writes. There is hope for you and for me. We *can* be free from these identity-defining lies. Regardless of your setting (past or present) God is the Master Storyteller and he can weave his grace and hope throughout your plot.

And smudgy pages? Well, God loves to write on those too.

Truth from God's Word

God has given us power to defeat the Enemy both in our minds and our hearts. Take some time to read and meditate on these Scriptures:

- ❖ Esther 3:13-4:14
- ❖ Job 38:1-42:3
- ❖ Psalms 139:1-16
- ❖ Isaiah 45:9-12
- ❖ Acts 17:24-28
- ❖ Romans 9:18-21
- ❖ Colossians 3:1-4
- ❖ 1 John 5:19-20

The Story's Characters

(Lies about Acceptance)

*Too often my identity and my feelings of love,
acceptance, and belonging are based on what
others think of me (and what I think of myself).*

What do Jo March, the White Witch, Professor Albus Dumbledore, Anne Frank, Loki, Atticus Finch, and Elizabeth Bennet have in common? They are all characters from stories loved by millions all over the world. Some of them shine as the central character; others play a supporting role. But all add something to the tale in which they appear. None of the stories would be the same without them.

Our real life stories have a host of characters too. Some play major roles in our lives, appearing in nearly every chapter and taking up pages and pages, while others enter into one brief scene and flit back out, never to be seen again. Some of them are beloved characters, evoking precious memories and heartwarming feelings. Some play darker roles, leading to

19

pain and doubt and lies. Though we might not like to admit it, the characters in our lives shape us and our stories greatly.

From the moment we are born our lives are a tangle of relationships that affect how we view the world, others, God, and ourselves. It is in these relationships we learn how to love... or how to hate, how to forgive...or to hold grudges. It is in these relationships our perception of ourselves is formed and nurtured...or abused. But whether our primary relationships are good or bad, we all have a need to belong. Each one of us wants to be loved and accepted, to know we have a place within a community (be it a family or some other social circle). In fact, the need to belong is every bit as much a part of being human as is our need for food and shelter. This is because God *designed* us for community.

In a perfect world—the one God originally designed—every person would find his or her need for belonging met in God. All our relationships with people would be good and whole. Our family, friends, and acquaintances would serve as supporting characters in the beautiful story of our lives. But because of sin we don't experience this. Instead, we often experience rejection, ridicule, even abuse—all the cruelty life has to throw at us—and the vulnerable place in us becomes wounded.

Oh, how the Antagonist loves to capitalize on this hurt! He inserts his lies and causes us to doubt our own worth. We become obsessed with finding the acceptance and belonging we intuitively know we need. Unfortunately, we look for it in all the wrong places.

Instead of running to God who offers us unending love and acceptance, we doubt his love and seek it from other characters in the story, elevating their opinions to a place above God's. This misplaced affection only leads to more hurt which leads to greater insecurity which, in turn, leads to continued desperate seeking. The lies in this section address this need—this obsession—to love and be loved, to belong.

Lie Number One: I have to fit in to be liked and accepted.

I stood huddled against a corner of the building while a group of girls stood around me, laughing and pointing. That day it was my dress they were making fun of, but there had been many other things before and would be many more to come before that terrible year was over.

Sometimes the lies we believe beset us as adults, but many, many lies take root in our minds and hearts while we are still children. We carry them like despised textbooks, often for most of our lives. For me the first and most engrained lie of acceptance was this one: I have to fit in at all costs.

I certainly didn't start life with this perception. I was very confident and self-assured as a young child. I had no reason to be otherwise. Everyone—family, relatives, close friends—adored me (at least as far as I knew). When I started school, I took to it like it was candy and had the admiration of my teachers as well. The small version of me had no reason to doubt I was loved and accepted. But everything changed in fifth grade.

Fifth grade started like any other year. It was my second year at a small Christian school where each classroom housed two grades. I was especially excited to make the acquaintance of the sixth grade girls, since there was only one other girl (I'll call her Wendy) in fifth grade besides me. One of the sixth grade girls in particular (I'll call her Jessica) caught my eye. Jessica was outgoing and friendly, and we'd soon struck up a friendship. I even invited her to spend the night at my house. We had a great time together, so I have no idea why everything changed after the sleepover, but it did. Suddenly Jessica was showering all her attention on Wendy and excluding me.

I wouldn't have minded her befriending Wendy. I was fine with all the girls in the classroom being friends, but Jessica had other plans. She quickly rallied the other girls around Wendy and herself, forming a clique from which I was forbidden.

In fact, her charisma was so great in that classroom even the boys were won over. I found myself friendless with no indication why. No one would sit with me at lunch. If I tried to join any of them, they would get up and move to another table. No one would play with me or even speak to me on the playground, unless it was to tease and taunt me. I spent each twenty minute period huddled in a corner by the building. My teacher chose to do nothing.

This in itself would have been devastating to any eleven-year-old girl, but it was not the only torture I endured that year. As the year progressed, I began receiving hate mail. Sometimes it was passed from student to student and slipped to me when the teacher wasn't looking. Other days I found it in my desk or backpack. It was more than mean; it was vitriol. I was told I was ugly and no one liked me—that, in fact, they *hated* me. I was told they wished I would leave their school and never come back. I was told they wished I were dead. One particularly horrible day they even went so far as to say they would kill me if they could. If I was caught crying over this nastiness, I was teased mercilessly for being a crybaby.

At first I tried to laugh these offenses off. Then I tried to swallow them down. Eventually, my parents got involved. They sought help from my teacher who chalked it up to girl hormones and said he'd try to keep an eye on things. Unfortunately, most of it happened when he wasn't looking.

The principal wasn't much more helpful, though he did call Jessica and Wendy into his office. They feigned innocence, told him they were only joking, and promised never to do it again—a promise they promptly broke. My parents even set up a meeting with Wendy's parents. She was penitent, explaining she hadn't realized at first what was happening and saying she felt pressured by Jessica, which may well have been true. She even apologized, smiled sweetly, and promised once more not to do it again. But nothing changed. Fifth grade girls can be as heartless and two-faced as a Disney villain.

though I did have the support of family and a few close friends, I still fought the notion that I had to fit in. By the time I went to college, I was more than ready for a new start.

But the trouble with lies is they follow us wherever we go.

But the trouble with lies is they follow us wherever we go. I expected to meet all kinds of new people and have a ton of fun in college, but my lack of confidence in myself and my ever present wariness of what others were thinking of me made me timid. And though college is certainly more open to diversity than high school, it does not reward the timid, at least not socially.

Why I thought it a good idea to go to college far from my home and my support system I do not know, but I left behind my parents (who were my buttresses), my younger brother (my lifelong pal), my best and most cherished friend (my kindred spirit), and my boyfriend of nearly a year (who later became my husband). Everything grounding me, except for God, was some twenty-odd hours away. Though I was excited about this new season of life and convinced these would be my best years, it quickly became apparent the insecurities which had plagued me since my 'tween years were doggedly dragging behind me still.

Perhaps my expectations were unrealistic. Looking back, I think I expected instant and lasting friendships. But friendships take time, something my insecure heart could not accommodate. I wanted to make friends and be included, but my idea of included meant being invited. It never occurred to me to say, "Oh, you're all going to get ice cream? May I join you?" And even if it had occurred to me, I'm not sure I would have had the courage to actually say the words. So I watched forlornly as groups of girls from my floor forged friendships and went on outings together.

No one was mean to me. Everyone smiled and chatted and joked with me whenever I was around. But no one *invited* me, and an invitation was synonymous in my mind with

inclusion, and inclusion was synonymous with *acceptance*. I assumed that even if people seemed as if they liked me, they were only pretending. They didn't *really* want me around. I started hiding in my room and studying.

I'm sure the girls on my floor thought I was some kind of nerd or recluse. All the while I was convinced no one really liked me. If they did, I told myself, they'd try to include me. By the time people did start including me, I was certain they didn't *want* me, so I politely declined their invitations. College turned out to be a very lonely time. I spent three miserably isolated years, studying hard in order to graduate early and return home where I felt belonging.

But the lie trailed along like an unwanted bit of toilet paper stuck to my shoe. Wherever I went, I felt like people were sizing me up and seeing something which made them want to turn their heads, either out of polite sympathy or in derision. At work, at church, at MOPS, in every circle in which I found myself, I couldn't shake the feeling people didn't really like me, didn't *really* want me around because they didn't invite me, didn't *seek* to include me. It never occurred to me maybe they were feeling just as self-conscious, just as awkward, and just as insecure as I was.

The reality is, most of us struggle from social insecurities. Those who blaze through life wrapped in a cloak of confidence are few. Those who are confident and kind are fewer. And those who are confident, kind, and also have the ability to notice and include others are rare indeed. Most of us struggle to forge one or two really good friendships to which we cling with tenacity. The friendships which seemed to occur all around me were most likely hard-won relationships. But all I could feel was the rejection of watching others get together for dinners or park dates with kids. Why wasn't I ever included?

It's not that I don't have friends. I do (and did even back then), and I was and still am thankful for them. I have two dear friends in particular with whom I have shared most of my adult

life. Our families are friends; our kids have grown up together almost like cousins; we've been there for each other's best highs and deepest lows. But the Antagonist has a way of bringing his nasty lies ever to the forefront, blinding us from seeing the truth, so I walked through this fog for much of my life.

It's only been recently that God has freed me from this lie. I've come to understand most people feel some measure of insecurity. Most people don't reach out much beyond their immediate family and tight friend group. So many hurdles—like fear of rejection, feeling inadequate as a host, or a lack of space or confidence in their homes—prevent people from reaching out to others.

I have gained the confidence and passion to become the one doing the inviting and including. Having experienced the pain of being an outsider, and knowing I can show God's acceptance to others motivates me to offer his hospitality to those around me. And yet, every once in a while, the Antagonist tries to slip this lie back into my story. If a particular lie keeps reoccurring in your story be vigilant, my friend. Take those thoughts captive and renew your mind! God's truth *can* set you free.

Truth from God's Word

God has given us power to defeat the Enemy both in our minds and our hearts. Take some time to read and meditate on these Scriptures:

- ❖ Proverbs 3:3-4
- ❖ Matthew 5:43-47
- ❖ Mark 9:35
- ❖ Luke 6:22-23
- ❖ Luke 14:7-14
- ❖ John 15:14-21
- ❖ Romans 12:9-21
- ❖ 1 Peter 3:9-11

Lie Number Three: I have to meet others' expectations of me.

We sat at the kitchen table together, flipping through a catalog and chatting. She sipped coffee while I downed a bowl of Cheerios.

Such a simple memory, but I treasure it. It was the first time I realized my mother had become my friend. No longer was she simply the one who cooked my meals, washed my clothes, and made sure I minded my manners; she was now a woman I enjoyed spending time with—chatting or shopping or working on projects. Though I was in high school, my mom was someone I looked forward to being with because I genuinely thought of her as my friend. In college she continued to be my support even though we were miles apart. I had no reason to believe anything would change when I got married. But it did.

We live every day of our lives with expectations. We hold expectations about life and about others. Some of these are reasonable: my husband *should* expect me to be faithful and invested in our marriage; my children *should* expect me to love and care for them. But other expectations are not reasonable; we cannot meet them even if we try. We cannot, for example, ensure someone else's happiness, nor can we validate someone at their core. Yes we can love, accept, and support others—which is a form of validation—but the soul-deep affirmation each person longs for can only come from God. There is no way we can take the place of God in someone else's life. And when we try to meet expectations only he can meet, we set ourselves up for disaster. I know because I've tried.

My husband and I had been married for only six months when it came time to navigate the holiday season. We both had younger siblings at home, so we wanted to stay connected to our families. Besides, we loved both families tremendously! Thankful we lived only three hours from our home town, we

agreed it made the most sense to spend Thanksgiving and Christmas Eve with one family and Christmas Day with the other. I'm not sure how we determined which family got what holiday that first year, but my husband's family got Thanksgiving/Christmas Eve while my family got Christmas. Both families agreed to and seemed fine with this arrangement, but unbeknownst to us, my mother had an expectation even she was unaware of.

My mom absolutely loves Christmas, and she was delighted we'd be at her house for her favorite holiday that first year. She looked forward to it with great anticipation, making all kinds of plans for our time together. My husband was still in college, and I was teaching at a junior high school, so neither of us had a job we had to rush back to after Christmas Day. Consequently, my mother assumed we'd spend a bit of the holiday season with them. In our newlywed minds, though, we were planning on spending just a couple of days with my family.

It was an innocent miscommunication. And it might have been easily remedied except for the fact that my husband's grandfather was diagnosed with cancer. No one could pinpoint how long he had to live, and my father-in-law wanted to be sure everyone saw him one last time, just in case. Combining pleasure with commitment, he arranged for the entire family to go on a ski trip after Christmas, including a jaunt to see Grandpa during the four-day trip.

Wanting my husband and me to participate with the family, and knowing we lived on a shoestring budget, he offered to pay our way. Of course we agreed! My husband wanted to see his grandfather, and we were both excited about the prospect of a free ski trip. The only trouble was, we were scheduled to leave the day after Christmas.

Looking back, the biggest problem surrounding this whole episode was a lack of clear communication. We didn't communicate enough information with my family soon enough.

When my mother did discover we were leaving the day after Christmas, it threw water on all the plans she'd been anticipating for months.

In addition, though I sincerely believe we told her the underlying intent of the trip, all she remembers is the fact that we had spent Thanksgiving with my in-laws, were going to spend Christmas Eve with them, and now were also slated to go on a post-Christmas ski trip with them while all she got was Christmas Day. She felt cheated and hurt.

At the time she said nothing but tried, instead, to swallow her pride and expectations and let us go. But the Antagonist is cunning and saw an opening. He snuck into her mind and planted lies: we loved the other side of the family more; we didn't want to spend time with her; she was relegated to second best. Of course, none of this was true. I adored my family and was happy to spend time with them. My husband liked them and enjoyed their company as well. Neither of us wanted to avoid them. But the lies were planted, and like an untreated wound they began to fester.

Before I go any further, I'd like to say my mother is a loving, self-sacrificing, and godly woman. Even throughout the difficult period of our relationship, she never stopped loving me or giving to me. I, in turn, never stopped loving her or wanting to please her. But she bought into a lie she just couldn't shake, and it shot an arrow of poison through our relationship.

She began to see all our actions through a lens of untruth and reacted with hurt and rejection. This sudden and unexpected shift in my mother's frame of reference caught us off guard. We couldn't figure out what was wrong, and we didn't know how to react, not the least because we felt we were being unjustly accused of things we hadn't done. Furthermore, it seemed no matter what we did, we just couldn't get it right.

I especially found myself trying to meet expectations that simply could not be met. I didn't understand this woman who exhibited jealously and possessiveness. It certainly wasn't the

mother I'd grown up with. We apologized; we tried to be fair and reasonably sensitive. Sometimes it seemed the problem was resolved, only to have it rear its ugly head again. We found we had to walk on eggshells around my mother. This went on for years. It was exhausting.

Not only this, it affected our marriage. My husband grew hardened in his attempt to shield me from the pain and sought to limit our time with my parents. I, on the other hand, remembering the mother she'd once been, resented his interference and tried endlessly to figure out how I could placate her.

Eventually, we both got to the place where we wanted to avoid contact with my mother altogether since it invariably resulted in conflict and hurt. Like a festering wound creates pain and distraction which cannot be ignored even as one tries to go about daily living, so this lie, and the subsequent consequences it created, festered in our relationship, sometimes in the foreground and sometimes in the background, but always, always there.

Our tendency to feel beholden to the expectations of others often stems from an unhealthy *independence* from God. In a backlash of dishonor towards him, we place higher emphasis on the opinions of people. I know I struggle with this. I transfer to others what belongs to God. Perhaps you do the same.

When we allow other people to dictate the expectations we must meet, we run the risk of destroying not only our confidence and our perceived identity, but those relationships as well. Whole beautiful chapters of our story are stolen by the Antagonist.

> *...the only expectations we must meet are God's.*

Dear friends, the only expectations we *must* meet are God's. And his expectations—unlike those others put on us or those we put on ourselves—though not *easy* to implement, are not overwhelming *(Mt. 11:28-30, Jn. 6:28-29)*. All he requires is that we believe, trust, and obey *him*.

I've made great gains in overcoming this lie, but sometimes I still find myself trying to meet someone else's expectations of me. I have to actively work at taking this lie captive. Similarly, my mother has finally seen some success in overcoming her lies, though I know she also battles to keep the upper hand. Together we've made good strides in mending the breech in our relationship, but the memory is still there—a scar we'll likely carry for the rest of our lives. We lost wonderful, beautiful years which we cannot get back. We can only move forward.

This is why it is so important to address the lies as you become aware of them. Just like Jo's manuscript was burned up in Louisa May Alcott's *Little Women*, the chapters the enemy takes are lost. But new ones can be written by our loving Author, and the sooner the better!

Truth from God's Word

God has given us power to defeat the Enemy both in our minds and our hearts. Take some time to read and meditate on these Scriptures:

- ❖ Psalms 119: 57-60
- ❖ Proverbs 3:27-30
- ❖ Matthew 10:37-39
- ❖ Matthew 11:28-30
- ❖ John 6:28-29
- ❖ Acts 4:13-20, 5:27-29
- ❖ Acts 24:16
- ❖ Romans 13:7-10
- ❖ Galatians 1:10
- ❖ 1 John 4:19-5:5

Lie Number Four: I have to be everything to everybody.

I'd sent the children outside. I couldn't deal with them anymore. In fact, I couldn't deal with any of it anymore. All I wanted to do was run away. I sat at the computer looking at plane tickets to New York. I could do it. I could withdraw a large sum of money from our bank account, go where no one knew me, and start over.

Sure, it would be hard. I'd have to find a job and a place to live. But how blissful it would be to go to work and interact in stimulating ways with other adults rather than dealing with whining, bickering kids; to come home to a clean house devoid of toys and schoolwork and half-eaten sticky messes; to not have to take care of anyone but me; to have the freedom to do whatever I wanted whenever I wanted. I was tired of being everything to everybody. I just wanted to be me. Why *couldn't* I have some peace and quiet for once in my life?

And yet, I felt guilty. What was worse, I couldn't figure out how I'd gotten to this point. I hadn't always resented my family. In fact, I had loved my roles as wife and mother and homeschooler. But somewhere along the way, something had gone terribly wrong.

If the Enemy can get you to believe one lie, he'll likely add a second to it. The lie that I had to meet others' expectations of me ballooned into this one. Not only was I trying to meet all of their expectations, I was trying to meet all of their *needs* as well.

My identity was tied to the hats I was wearing. Wife, mother, teacher, friend, mentor—if I could do all this and do it well, surely I was *worth* something. I was seeking validation from others' dependency on me, performing like an employee who knows she's got job security as long as no one else can do her job.

But shouldering all the responsibility *and* the entirety of the execution is an almost sure recipe for burnout. Like that corporate employee, I felt this way in my stay-at-home job. Subconsciously I felt I had something to prove. (I still struggle with this, if truth be told.) I found myself alternating between pride at my ability to accomplish so much and despair because I really *couldn't* meet everybody's needs all the time.

About a year after the birth of our second child I began to experience a general overall decline in my health. For one thing, I was exhausted. Everyone, including my doctor, chalked it up to being a mom with a toddler and a preschooler. Of course I should be tired; it was normal, I was told. But this was more than sheer exhaustion from lack of sleep. This was a dog-tired weariness I felt in my bones and blood.

Still, I pressed on, adding an in-home business, homeschooling, and another child to the mix. In addition, I was an active member of our church and homeschooling communities. Externally I put on a good front, but internally I felt like I was dragging myself along rough pavement each day, scraping my physical and mental fortitude as I went. The longer I went and the harder I tried, the more I felt like a soul with road rash. I had no bandwidth left for the things I'd formally pursued. I lost my overall zeal for life.

Over the next three to five years, my body started to break down. In addition to the symptoms of chronic fatigue, I had all the symptoms of rheumatoid arthritis and began to exhibit the early symptoms of Multiple Sclerosis. All of this was painful, frightening, and demoralizing.

What I really needed was help, but I largely refused it. I was used to being strong and independent, and the proud part of me refused to give in. Somehow receiving help was, in my mind, a form of weakness. And I was terrified that if my family could do without me, it meant they didn't really need me anymore.

My life and routines began to break down. I would muscle through until I crashed (either physically or mentally or both) at which point my dear eldest daughter, who was only a middle-schooler, would shoulder my adult responsibilities—cleaning, cooking, even homeschooling and parenting her younger siblings.

It was incredibly unfair to her and I knew it, which only added guilt to the mix. But instead of sitting down with my husband and trying to figure out new and healthier patterns, I chose to ignore my own needs, continuing instead to try to be everything to everyone else. Eventually, I began to resent the very people I loved. Why did they require so much of me? I just wanted some peace and quiet for once with no one demanding anything of me! Which is how I ended up contemplating running away from home.

The truth is, I love all the roles I've acquired over the years. I love being a wife and a mom, a homeschooler and a mentor. I love my longtime friendships and the ones I'm currently forging. I love my connections with other writers and homeschoolers and fellow followers of Christ. But sometimes too much is too much. I *cannot* be everything to everyone. I cannot even adequately invest in all of these relationships and roles all of the time. I've had to learn to give in to the natural ebb and flow of life. People and roles come and go in my life and that's okay. I don't have to juggle all the balls. Even my long-term relationships are not always at the forefront. But just because one slips into the wings for a scene (or even an entire act) does not mean it's over. I've learned to give myself permission to let my relationships do this.

As for my family, they still come first. I still invest the lion's share of my time performing the daily tasks of wife, mother, homemaker, and homeschooler and investing in the lives of my kids and my husband. But I've also learned they'll be okay if I take a break for others or for myself. Taking a step back is not the same as neglect. For example, though I try to keep tabs

on where each of my kids are at in their thinking and growing process, I'm learning I don't have to meet all their needs or have answers to all their questions. It's okay to let them wonder, to let them struggle, to let them stretch and grow.

> *None of us can meet every need of every person in our lives.*

None of us can meet every need of every person in our lives. It's not humanly possible. If you identify with this overwhelming duty, it's time to realize it is not your responsibility. God is the only one who can meet every need your friends and loved ones have, just as he's the only one who can meet yours.

Truth from God's Word

God has given us power to defeat the Enemy both in our minds and our hearts. Take some time to read and meditate on these Scriptures:

- ❖ Psalms 23
- ❖ Psalms 55:22
- ❖ Psalms 62:5-8
- ❖ Psalms 127:1-2
- ❖ Jeremiah 31:25
- ❖ Matthew 11:28-30
- ❖ Romans 12:3-8
- ❖ Hebrews 4:9-13

Lie Number Five: People wouldn't accept me if they knew the mess I really am.

I uploaded a picture to social media that looked calm and serene, typed a Bible verse, and pushed send. But I felt like a fake. I didn't feel calm or serene that day; I was having trouble trusting God. Who was I trying to be anyway?

So much of our lives are spent hiding. This has always been the case, but in today's era of social media it's even more applicable. We curate our persona now more than ever. I choose what people see of me; you choose what people see of you. And if we're honest with ourselves, we really want people to see the best, the prettiest, the most accomplished. We want to be part of the "shiny, happy people" group.

True, some of us fight this fakeness—we intentionally post things to reveal our "real" life. But even those reveals are carefully chosen. We reveal when we want to, when we feel strong and confident in our identities. And we reveal in such a way that people will think all the better of us for being "honest," and "genuine," and "raw." But very few of us are honest enough to reveal the *really* raw side of life.

My whole life I was lauded for being smart, creative, responsible, and godly. I was a leader and an example—a model student, wife, mother, homeschooler, Christian. I'd earned a reputation I was proud of; I liked the image people had of me.

Much of it was true—reputations are earned for a reason—but there were (and still are) parts of my life no one but my family saw. Some were seen only by God. Those were the raw parts, the ugly parts. Those were the parts I *didn't* want people to see or even know about.

As my physical health deteriorated over the years, my mental health did as well. Some of it was tied to physiological issues, some of it was due to several incredibly difficult life circumstances which all occurred almost simultaneously, and some of it was fueled by my ever compounding despair and guilt at not being able to "crush it" in life. In any case, I became a person I hardly recognized. I called myself PsychoMom and felt almost schizophrenic.

On the one hand was the me I liked and was proud of, the me others knew and respected. And those good and noble characteristics *were* a part of me, but I also had a dark side. I had a temper I couldn't control. I would rage at my

kids—yelling, criticizing, blaming, and belittling them. I even resorted to roughly shaking and slapping one child who was particularly difficult to control. Some days I was despondent and moody, often for no apparent reason other than whacked out hormones. I became depressed. Eventually, I even became suicidal.

Never once during this struggle did I confide my true inner turmoil with anyone, not even my husband. I hinted at it from time to time with some of the women in my church, but I never revealed my full hand. I was sure if people really knew how ugly and messy my life had become, they would lose all respect for me. At very least their estimation of me would go down. It never occurred to me maybe they were struggling with silent demons as well. I couldn't fathom that honesty might lead to healing. The only thing I could imagine honesty leading to was shame and humiliation. So I kept it all inside. Better, I thought, to let people retain their perfect image of me than to add public humiliation to my ever growing list of things I couldn't cope with.

Friend, are you living behind a carefully curated persona? Does the demand to keep up appearances wear on you? I understand, but believe me when I say you *cannot* keep this up forever. At some point something will have to give. Please know there is far more grace in revealing your dirty laundry than you think.

Yes, there will be those who judge. But many, many more—the majority actually—will breathe a sigh of relief at your honesty. I cannot tell you how many people have thanked me for my willingness to pull back the curtain and reveal the real me. So many have said, "I thought I was the only one."

There is a reason God's Word tells us confession of sins brings healing. The very people you are afraid to show the real you are likely hiding equally deplorable natures. We all struggle with sin. It's time to stop pretending we don't.

Truth from God's Word

God has given us power to defeat the Enemy both in our minds and our hearts. Take some time to read and meditate on these Scriptures:

- ❖ I Samuel 16:7
- ❖ Psalms 51:1-4, 16-17
- ❖ Psalms 56:11-13
- ❖ Proverbs 15:33
- ❖ Proverbs 28:13
- ❖ Matthew 23:25-28
- ❖ Luke 6:20-26
- ❖ Luke 14:11
- ❖ 1 Corinthians 1:26-31
- ❖ 2 Corinthians 4:7
- ❖ Galatians 1:10
- ❖ James 5:13-16

The Story's Plot

(Lies about Performance)

*Too often my identity and my success are
based on what I do and how well I do it.*

I sat nervously in my chair, fielding questions from a panel of three older gentlemen. We'd covered the usual: *Why do you want this job? What are your top three strengths and weaknesses? Do you work well in teams?* But the next question floored me.

"So, would you classify yourself as a type-A or a type-B person?"

I knew the classifications. The type-A person is driven—full of energy and ideas. These dreamers whirlwind their way through life busy, busy, busy. Their brains are constantly going, coming up with new and innovative ways of doing things. And because they are a bundle of energy, they accomplish many of these ideas. They're the inventors, the politicians, the CEOs. They are, at least in Western terms, the accomplished and successful.

41

The type-B person is steady—no need to rush. These individuals know life isn't really going anywhere; it will be there tomorrow and the next day, until it isn't—which they're okay with too. They see no reason to get worked up over things; there's nothing they can do to change it anyway. They are often quiet and easy-going and spend their lives steadily doing the next thing.

As I sat in the job interview, I realized I hadn't ever really considered the question of whether I was a type-A or type-B person. Of course, I didn't have a lot of time to ruminate—it was a job interview, after all. Quickly, I racked my brain and told the interviewers, "I think I'm a type-A person in a type-B body." Everyone chuckled, and I wondered if it was good or bad to make these three older men chuckle in an interview. (I got the job, so it must have been okay.)

Since then, I've used that phrase many times over. It actually describes me perfectly. I'm a dreamer—an ideas person whose brain never rests—trapped in a body which cannot quite keep up. My body betrays me all the time. I tend to go hard until it crashes (which is far too often, in my opinion). If I had to liken myself to a biblical character, it would probably be Martha of Bethany. You remember, the busy one Jesus is always having to redirect *(Luke 10:38-42, Jn. 11:1-43).*

So which are you? Are you ideas and energy and hustle, or are you logic and measured and constant? Are you an epic tale of adventure full of action and excitement—*The Scarlet Pimpernel* perhaps? Or are you a thoughtful tome, plumbing the depths of mankind—maybe *Walden*. Whichever type of person you are, there are, more likely than not, at least *some* areas of your life where you struggle with how well you perform and how much you accomplish.

We live in a culture which validates people by these qualifications. Because so much of our life is filled with activity, this more often than not becomes the driving factor of our identities. We tend to think of ourselves and others based on

what we *do*. So often it's the first thing we ask each other: *"So, what is it you do?"* or *"What have you been doing lately?"* And it's how we identify ourselves: *"I'm an author,"* or *"All I ever seem to do these days is run kids around!"* What we do and how well we do it become the standard by which we gauge ourselves and each other.

> *What we do and how well we do it become the standard by which we gauge ourselves and each other.*

This performance trap starts early. Parents sign their kids up for basketball camps and cheer clinics while still in elementary school because they fear if they don't, their kids won't make the middle school team. And if they don't make the middle school team, there's no way they'll make the high school team, which means college placements and scholarships are out of the question. Though the intent is good, the pressure is real, even when parents are loving and supportive.

As far back as I can remember my parents were always telling me they loved me and were proud of me regardless of what I did. But I also remember even as a very young girl feeling like I had to *do* better and *be* better. I felt a compulsion to succeed, and anything less than perfect wasn't quite success. Like a cat frantically trying to pounce on an ever moving laser dot, I've spent a good deal of my life chasing after an illusion called perfection. In fact, so intense has been my pursuit, my very identity has been inextricably bound up in what I do and how well I do it. Both my confidence and my acceptance of myself have hinged in great part on my abilities or inabilities.

Some lies of performance are glaringly obvious—we type-A people *know* we struggle with them. Some are more subtle—I see your silent struggles, you type-B people! But all of them keep us chasing an elusive laser dot. The lies in this section focus on this performance trap.

Lie Number Six: I have to have the perfect appearance.

I stuffed the school pictures into my backpack. I would dutifully take them home to my mother who had ordered them, but I didn't want to look at them anymore. They only reminded me of what I already knew—I was ugly.

Our culture is obsessed with appearance. It's very hard to live in our media saturated world without being affected by this. Women are especially susceptible to this, though increasingly men struggle with body and appearance issues as well. But even before social media amped up the pressure to look perfect, I was struggling with body image. My issues did not revolve around the traditional issues of weight or shape, however. Mine stemmed from lifelong autoimmune problems. I have extremely dry skin (painfully so), which breaks out into a rash if you simply *look* at it wrong.

As a child and teen, I was almost continually covered in blotchy red wheals. These rashes itched and hurt, making me truly miserable. But equally as painful, or perhaps even more so, were the social effects this condition posed for me. As a child I was heartlessly teased. People called me alligator and other names which cut into my tender child heart. Sometimes I was even shunned, kids acting like I had some kind of disease they could catch. This made me extremely self-conscious about the way I looked. I became obsessed with eliminating any little physical flaw in my appearance (a tendency I still battle to this day). The trouble was I had very little control over these issues. When I couldn't control my body's appearance, I turned to fashion to compensate. At the very least, I figured, I could gain acceptance and improve my looks by adhering to the latest styles.

I don't think fashion in and of itself is evil. Clothing design is just as much an art form as painting or sculpture. For those who are fashion designers it can be an expression of God-given

gifts and talents. On an individual basis, style becomes an expression of personality. When born out of confidence, style can be a way to showcase our uniqueness and even bless others around us. (I've got a couple of friends whose confident style brings a smile to my lips whenever I see them. I find joy in how they revel in who God made them to be.)

But like many people, *my* fashion choices did not revolve around my uniqueness. Instead, I conformed to whatever styles were currently trending no matter how uncomfortable or ridiculous. There was a social standard to measure up to, and I was determined to meet it. My clothing was not an expression of my God-given personality. I didn't want to display God's character through what I wore. I wanted to fit in. I found myself in a never-ending fad based comparison game. I had swallowed the lie that my worth is tied to my appearance.

The trouble with pursuing trends, though, is they are a never-ending cycle, often demanding great financial expense as well. I managed to avoid much of this expense by being a pro at secondhand shopping. Still, this comparison based pursuit of the perfect body and appearance created a lot of discontent in my soul. I was constantly appraising myself in light of "the standard." If I felt I didn't measure up, I made myself work harder to get it right. This meant spending more money (even if it *was* at secondhand stores) and more time to look the part.

Not only was this fashion standard my task master, I also spent a lot of time comparing myself to others. I felt a need to be better dressed and more stylish than those around me. If I could outperform those in my social circle appearance-wise, it would elevate my status and, thus, my opinion of myself. This habit became so ingrained that to this day I have to constantly check my attitude and my comparing eye.

Ironically, this struggle with image is often a double-edged sword. In my comparison, I wrestled with feeling inferior to others, but I also unknowingly walked in pride and vanity. In a twisted mind game, I prided myself at being *unconcerned* with

my appearance and spending so little on my looks. I scorned the girls and women who were "obsessed." This is actually one of the hallmarks of any comparison game. There will always be someone who is better at 'XYZ' than you, forcing you to battle discontent. Likewise, there will be someone who is "inferior" to you, tempting you to be haughty.

I never in a million years would have considered *I* struggled with vanity. In my mind, other women struggled with it but I certainly didn't! This was especially true when our budget was so tight it was simply impossible for me to keep up with the trends in fashion. But the reality was, though I swallowed my pride and made due, it was still on my mind. I still envied those who could buy the latest styles or go get their hair and nails done. Envy is an outward symptom of a soul-deep sickness.

God has a way of humbling us. It's a very long story and one mostly unrelated to the topic of this book, but for several years God asked me to don a head covering. I'm still not totally sure why this was the avenue he took me down to learn several different lessons, but it is the case nonetheless. I might still be covering my head today if it weren't for an equally challenging journey God walked me through seven years later. But that, too, is another story for another time. In any case, I could not ignore what my God was requiring of me. So with much grumbling and dragging of feet, I donned the head covering and began trying to explain this new practice to people.

What was most interesting about this long-term exercise was what it revealed about my inner attitudes. Suddenly I was faced with the reality that I was vain after all and cared greatly about my appearance, especially as it compared to society's standard of perfection.

I can't say I ever *enjoyed* wearing a head covering, though I know many women who have found freedom and joy in doing so. But slowly over the years, my tight hold on the standard of perfection as it related to appearance loosened. Interestingly

enough, when I stopped wearing the head covering, I found myself struggling with this vice again. Today, my victory in this area comes and goes. Perhaps it will always be a battleground in my life, but at least I recognize the trap now; at least I am aware and *can* do battle as needed.

If the Antagonist has you critiquing yourself in the mirror or eyeing the woman next to you in comparison, please know <u>you</u> <u>are</u> <u>beautiful</u>. God designed you to reflect his glory, a beautiful calling indeed. But you cannot adequately reflect the glory of God if you are hiding in the dressing room of life convinced his glory doesn't fit!

> *...you cannot adequately reflect the glory of God if you are hiding in the dressing room of life convinced his glory doesn't fit!*

The truth is, the Antagonist has you looking at yourself through one of those wavy circus mirrors. What you think you see is not the person God made you to be. Stop looking in the mirror and instead look intently into the face of your Creator. It is there you will find the image of the real heroine of your story.

Truth from God's Word

God has given us power to defeat the Enemy both in our minds and our hearts. Take some time to read and meditate on these Scriptures:

- ❖ Psalms 139:13-18
- ❖ Proverbs 3:7-8
- ❖ Proverbs 4:20-23
- ❖ Proverbs 11:22
- ❖ Proverbs 31:30
- ❖ 1 Corinthians 3:16-19a
- ❖ 1 Corinthians 6:19-20
- ❖ 1 Timothy 2:9-10

Lie Number Seven: I have to be the all-American woman.

Important! This is your last notice. Renew now to enjoy uninterrupted continuation of your subscription. Otherwise, this is your last issue!

I held the cardstock flyer in my hand. It was tempting. But I knew what I had to do. For the good of my soul I needed to let this magazine subscription expire.

Our society has an image of what a woman should be. It is utterly impossible to achieve, but so many of us try. We are supposed to be strong and assertive yet gentle and caring. We are supposed to be fashionable and have magazine worthy houses. We are supposed to be well-educated and successful in our jobs while still managing our homes and families. If we choose to be a full-time homemaker, our choice is given lip service, but in reality our social status is degraded. Whether we stay home or pursue a career, we are supposed to have well-behaved, extraordinary children. We are supposed to be involved in our communities. We are supposed to do it all. To be an American woman is to struggle with this persona.

At first I was unaware of this image; striving to achieve it was merely a subconscious undercurrent in my life. But at some point I did become aware of the hamster wheel on which I was running. Awareness is helpful but it is not the cure. Awareness can be a tool—a weapon to fight the battle—but it cannot take the place of truth. The only way I know to combat this lie is an unending commitment to renew my mind with biblical truth. God doesn't want all-American women, he wants God-kingdom women!

There are so many little ways the stronghold of this lie has made itself evident in my life. We already discussed the fashion element, but I struggled with home image as well. When it came to having a designer caliber home or one in which people

felt welcome and at ease, I had to make a conscious choice. I remember clearly the day this came into focus for me.

For several years I subscribed to a home magazine. I liked the pretty pictures, the ideas, and the inspiration. But a growing discontent was gnawing at my soul. I found myself frustrated I couldn't have a house like those featured in the magazine. I felt jealous of those who could afford the kind of furniture and décor I wanted. I even found myself resenting my children whose obligatory toys brought clutter into my home and whose very existence created unseemly disorder rather than picture perfect spaces. One day I found myself begrudgingly looking for a place to hang up yet another round of marker "art," wishing I didn't have to display these stick figure families and scribbles—it was ruining the decorating look I was trying so hard to curate.

That day was a wake-up call for me! I didn't *want* to resent the tender expressions of love my little ones were creating for me. I realized steeping my mind in "ideas and inspiration" was resulting in covetousness and unrest. I ended up having to cancel the magazine subscription and avoid trips to certain stores for a time while I cultivated a contented heart.

Not to say it was easy. As soon as I tamed one all-American monster, another would rear its ugly head. About the time I was no longer struggling with my home image, I discovered I was bent on having the best children—the smartest, most accomplished, better behaved, you name it. I know I'm not the only one who struggles with this. I know because I've been in more than one "my kid is better than your kid" conversation. Oh, we don't come right out and say it, but it is the underlying spirit of the conversation. This comparison game may be the most insidious of all. It diminishes our dearest, most precious gifts to pawns to be moved at our whims for the sole purpose of check-mating an equally precious person and her dear sweethearts.

Friends, it is time to put an end to these pursuits. The image of the all-American woman is as elusive as fog. Though

it surrounds us, we can never lay our hands on it. Better to pour our hearts—our time, money, talents, and energy—into becoming mighty women in the kingdom of God! What this looks like for you will be different than what it looks like for me, for the very reason God has gifted each of us differently and uniquely to fill a particular role in his grand plan. You have a role to fill in his kingdom and so do I, and no one can take our places!

Truth from God's Word

God has given us power to defeat the Enemy both in our minds and our hearts. Take some time to read and meditate on these Scriptures:

- ❖ Psalms 37:1-11
- ❖ Psalms 119:33-40
- ❖ Psalms 127:1-2
- ❖ Proverbs 14:1
- ❖ Proverbs 15:16-17
- ❖ Proverbs 16:8
- ❖ Proverbs 17:1
- ❖ Ecclesiastes 2:17-26
- ❖ Ecclesiastes 5:10-11
- ❖ Jeremiah 17:7-11
- ❖ Matthew 6:19-34
- ❖ Ephesians 1:15-2:10

Lie Number Eight: I have to be the perfect Christian.

My daughter groaned. The theme for the girls' youth retreat had been announced—it was Godly womanhood...again.

"Why can't they ever talk to us about anything else?" she asked, the frustration in her voice real. "The guys get to do

all kinds of fun things and talk about all kinds of topics, but all we ever get to do is make crafts and paint our nails and talk about modesty and having a 'gentle and quiet spirit'!"

I couldn't help but cringe. While women's rights** have widely been accepted as a fact in society at large, the Church still struggles with seeing women as strong and vibrant and multifaceted assets in the kingdom of God. It isn't what I want for my daughters. It isn't what I want for myself.

As if the image of the all-American woman isn't hard enough to achieve, many women who profess a belief in Jesus Christ are striving to meet an even higher benchmark. Most Christian women are subconsciously trying to achieve the all-American standard, as well as a whole slew of other expectations the Church intentionally or unintentionally lays on them! Daily devotions, modest dress (though the definition for this is inconsistent), marital submission, corporate submission within the church, and an overall "gentle and quiet spirit" top the list of expectations for Christian women.

Before we go on, please do not jump to any conclusions here! I am not saying all of these are bad. What I am saying is the expectation load can be overwhelming and discouraging. In addition, these biblical virtues can become idols, taking our eyes off of Jesus and putting them on external rules.

Spiritual practices which should be forms of worship to God become more important than the One they are meant to honor.

For example, I was taught my whole life that I should have

> *Spiritual practices which should be forms of worship to God become more important than the One they are meant to honor.*

** I know this is a loaded phrase. By women's rights I do not mean an anti-biblical feminism. But both Jesus and the Early Church were known for their radical egalitarian treatment of women! Women were (and should still be) seen as co-heirs with Christ and co-laborers in the work of his kingdom.

a daily quiet time. There is good reason for this. Reading the Bible and connecting with the Lord in prayer is vital to our spiritual health. It is something I personally strive for because I have learned how beneficial it is and because it brings me joy and peace. But this was not always the case.

As a sleep-deprived mom of toddlers I found it impossible to maintain a "sacred" devotional hour with Jesus before my day started, especially when my kids consistently rose with the sun. I tried maintaining an evening devotional practice, but it was generally a dismal failure. After the kids went to bed, I was playing catch up on all the necessary tasks of daily living I couldn't accomplish when they were awake (things like laundry and dishes). At the end of the day it was all I could do to fall into bed in exhaustion. Devotions became a source of guilt rather than a source of comfort and strength.

Perhaps you can identify? I found the following helpful when my mother shared it with me years ago. I hope it helps those of you who are finding guilt in this area of Christian living.

For millennia most Christians did not have access to Scripture on a daily basis. The New Testament didn't yet exist for the early Christians. And though there were the Old Testament writings, most did not have their own copies; they had to rely on what they had memorized.

During the Early and Middle Ages, manuscripts of any kind were scarce, and most people didn't know how to read; the church held a monopoly on the Scriptures. Until the invention of the printing press, most believers had little to no access to Scripture on a daily basis.

Our modern idea of daily devotions consists of reading the Bible and praying in order to develop a relationship with God—to be instructed, guided, and comforted by him. But if so many Christians had no access to the Bible, how did this relational interchange take place?

My mother suggested to me that people had to rely on what they received during their worship gatherings to carry

them through the week. This did *not* mean they could go to church and then forget it for the next six days. It *did* mean they couldn't have a quiet time as we envision it now.

So what *could* they do? They could pray, of course—open communication with God is a primary way by which we grow our relationship with him and dependency upon him. They could also strive to memorize Scripture. (This was often done through catechisms and liturgy.) And they could meditate on what they had heard preached to them the Sunday before. All of these, along with songs and hymns and spiritual songs, were viable means of growing and maintaining a vibrant faith.

If you are in a season of your life where a daily quiet time is hit or miss, do not despair! You are not a lesser Christian in God's eyes. Does he yearn to spend time with you? You better believe it! After all, you are his Bride. But nowhere in Scripture is there a prescribed formula for what this has to look like.

Fellowship with God may very well include daily prayer and time in God's Word—the Bible feeds your spirit, so read it whenever you can, even if it's just for five minutes! But it might also look like singing hymns or praise choruses at the top of your lungs with your preschoolers. Or setting a daily alarm on your phone to stop and pray for a minute with your older kids. Or posting Scripture around your home or in your car to read and memorize as you go about your day. Set aside the American idea of daily devotions and explore your relationship with God in a fresh new way!

Right about now some of you are feeling wary. Please, don't throw the book away yet! I'm not saying devotions, submission, modesty, and a host of other feminine Christian expectations aren't biblical principles. (Those are conversations well beyond the scope and purpose of this book.) But I am saying they are often elevated above what *God* requires. Like the Pharisees of Jesus' time, the modern church has put a burden on women harder to bear than what God himself asks of his daughters.

When I was observing the practice of head covering, fellow Christians had all kinds of opinions regarding what I was doing. Almost everyone believed my practice was somehow affecting my standing with God, either for better or for worse. Those who thought I had finally received Holy Spirit revelation were convinced I was going to experience more joy, more peace, and more of God's power in my life. What they didn't consider was my heart attitude regarding the head covering. The only thing which mattered to them was the *external action*.

Those who thought I had somehow fallen into deception were sure I was putting myself into bondage and urged me to live in the grace Jesus had bought for me on the cross. They just could not conceive that this external action might be born out of *obedience* to something my Savior had asked me to do. Surely, they thought, it was legalism at best and demonic deception at worst.

The fact that both opinions existed within the Body of Christ was disheartening. It highlighted more than ever for me how tied we are to external actions and performance when it comes to our relationship with Jesus and with each other.

I think most Christians truly desire to live in the grace of God, but the reality is, very few even begin to comprehend God's grace, let alone live it. And because each and every one of us is different, with different personalities and struggles, God's grace is going to look differently in each of our lives. Maintaining a glossy image of a "good Christian" is detrimental to the Body of Christ as a whole and to each and every individual who is striving to meet this "godly" standard.

Please don't misunderstand me. I do believe there *are* biblical mandates for God's people. Likewise, just because a particular practice is not *explicitly* required by God—like daily devotions—does not mean it should be thrown out. In fact, it might actually be helpful! Just be sure the standards and practices you are *requiring* of yourself and others are the ones God requires of you, not the ones foisted on you by our

culture. How can you know the difference? The wrong standard will likely bring guilt. Those practices which the Holy Spirit is cultivating in your daily existence will bring you abundant life!

Truth from God's Word

God has given us power to defeat the Enemy both in our minds and our hearts. Take some time to read and meditate on these Scriptures:

- ❖ Psalms 119:10-16
- ❖ Jeremiah 17:7-8
- ❖ Matthew 5:3-10
- ❖ Matthew 6:1-18
- ❖ Luke 18:9-14
- ❖ Romans 3:20-28
- ❖ Romans 4:4-5
- ❖ 2 Corinthians 3:6, 17-18
- ❖ Galatians 2:16
- ❖ Titus 3:4-7

Lie Number Nine: My identity is based on how I compare to other people.

I remember whipping open the school newspaper to the page with the senior superlatives, anxious to see if I'd made the cut. But my excitement quickly turned to embarrassment. I sank low in my seat, my face burning. While some people were voted "Most Likely to Become President" or "Best Dressed" or "Coolest Car," I was voted "Biggest Brown-noser."

Looking back now I can shake my head and laugh, but at the time I was mortified. For one thing, I didn't agree with the sentiment. I've always been an "old soul" and genuinely enjoyed the company of adults even when I was a child. Talking to my teachers—asking them about their weekend or comparing

favorite brownie recipes—seemed as natural to me as comparing opinions about the latest movie with my girlfriends.

Only no one else saw it this way. And if I'm honest, I knew it. The whole time I chatted sincerely with my teachers, I was also aware that it raised their perception of me. If my natural inclination to be friendly gave me an edge in the class…well, I wasn't going to turn it down. Still, I was indignant over having been pegged this way, especially when I had strived and succeeded in so many other areas. Why couldn't I have been voted "Best Actress," or "Nicest to Everybody," or even nothing at all.

We talked a lot about my struggle with lies of acceptance in the first section of this book. In each of those instances, I was seeking the acceptance of others. But there was an even deeper acceptance I was seeking, though I wasn't even aware of it. Even as a young girl I was very cognizant of how I measured up compared to those around me. I prided myself in being better—a better student, a better friend, a better actress, a better wife, a better housekeeper, a better mother, a better Christian.

But what looked like merely an external issue was actually a struggle for acceptance with *myself*. In addition to having to earn everyone else's acceptance, I also had to earn my own acceptance by being better at everything I tried to do and be. Eventually, this comparison game took its toll, because there was no way I could be better at absolutely everything!

The comparison game was, and still is, a double-edged sword for me. On one side of the sword, I look at others and see myself as better. I've battled pride my whole life; I still struggle. It is why I was so incensed at my senior superlative. In my mind I was far better in any number of other categories than the person who had been voted "best."

In elementary school, I was sure my school projects were better. In high school, my acting was better. In college, I was more spiritually mature. As a homemaker, my house is cleaner. As a mother, my children are smarter, more talented, or better behaved. The list goes on and on.

Yet, on the other side of the sword, I look at others and see how exceptional *they* are. I'm aware of where I fail. I'm far less patient with my children. I'm less organized or creative in my homeschooling. My relationship with my husband isn't as tender. I'm the slowest writer in the group. My marketing and social media are less effective. That list goes on and on too.

A couple of years ago I had the privilege of being a guest on a podcast. My friend and I were asked to discuss creating a culture of beauty in the home. While I was preparing for the podcast, God showed me something I'd never considered before. Comparison is a form of covetousness. It can even rise to the place of an idol. If I wish some element of my life were like yours (comparison), I am in effect coveting what you've got, even if what I'm craving isn't a possession.

> *Comparison is a form of covetousness.*

It's easy to spot coveting when what we've got our eye on is a bigger house, a nicer wardrobe, or a fancier vacation. But what about a solid marriage, respectful children, a congenial relationship with the in-laws, or a peaceful countenance? Just because those things can't be bought with money does not mean they fall outside the realm of covetousness. If I alter my life to pursue something you've got without first seeking whether God wants *me* to strive for it, then my desire has become an idol to me.

This is such a sneaky lie. So much of what we covet in others is genuinely good. But if you are pursuing something because you're trying to improve your standing in comparison with others, it's probably time to face the fact you've bought into this subtle lie.

Our God is a personal God. He doesn't write pulp fiction. Every single detail of your life—the setting, the characters, the plot, even the conflict—has been outlined by God to result in a unique story! Formulized writing is uninspiring. (Even a

fifth-grader begins to realize Nancy Drew has solved the same basic mystery ten times already!)

But our God is the source of all inspiration and true Life, and he wants your story to convey that Life to the world around you. Stop trying to steal elements from someone else's story—they're not going to fit! Take those thoughts captive and realign your heart to seek God's place for you in his kingdom, not your place compared to those around you.

Truth from God's Word

God has given us power to defeat the Enemy both in our minds and our hearts. Take some time to read and meditate on these Scriptures:

- ❖ Psalms 62:9, 11-12
- ❖ Isaiah 45:9-12
- ❖ Matthew 6:1
- ❖ Luke 9:46-48
- ❖ Romans 9:20-21
- ❖ Romans 14:4, 7-13
- ❖ 1 Corinthians 12:4-31
- ❖ Galatians 6:2-4
- ❖ James 4:11-12
- ❖ 1 Peter 1:13-23

Lie Number Ten: I have to do it all on my own.

Remember how I said I am like Martha of Bethany, the one who hosted Jesus? Well, this might be true except for one little detail. She interrupted Jesus' chat with Mary to get some help from her sister *(Lk. 10:38-41).* But somewhere along the way I got the idea that letting others help me was a sign of weakness, that I somehow invalidated my worth by admitting I couldn't do it all. I took pride in my ability to juggle all the

balls and keep all the plates spinning. It made me feel better about myself, even as I was making myself literally sick.

It started with the desire for perfection—an incessant taskmaster which never let me rest. When the babies were sleeping and I should have taken a nap right alongside them because I wasn't really sleeping at night, I chose to clean the bathrooms and do laundry instead. Over the years I kept adding kids and responsibilities (like homeschooling and a home business) without letting go of any of those expectations. I was sure I could superpower my way through and do it all.

And amazingly, I did...for a while. I kept the house clean and relatively tidy. I made home cooked meals seven days a week (most of the time). I taught the kids to read while entertaining toddlers. I hosted scrapbooking crops and did home shows. I somehow managed to keep my husband relatively happy. And I grew more and more prideful, secretly looking down my nose at those who couldn't manage to do it all. Little did I know their piles of dirty dishes and corner dust bunnies were not necessarily a sign of laziness but of properly ordered priorities!

Unfortunately going, going, going and doing, doing, doing were taking their toll. Slowly and silently my body was breaking down. First I was tired; then I was exhausted, eventually to the point of barely functioning. I began to have pain in my joints. Finally, it got so bad I couldn't brush out my daughters' hair. I began to experience the beginning symptoms of MS. I had chronic rashes and extreme insomnia (most nights I slept only 2-3 hours). I had hormone swings and entered early perimenopause, complete with all the hot flashes, night sweats, and other symptoms which come from those hormone changes. Probably worst of all, I had deep neurological itching (like your worst mosquito bite times ten but deep in your nerve endings).

Of course, we tried to address these issues. I went on elimination diets and cleanses. I tried pharmaceuticals and natural remedies. I was tested for food allergies and found out

I was allergic or sensitive to 50 different foods! Still my health declined. I began blacking out for no apparent reason. Then I started losing muscle control—I would tell my leg to move in my mind but it wouldn't move. All of this was incredibly scary and frustrating…and it ate away at my identity.

Remember, I had prided myself on how much I could do. I was trying to be everything to everyone, meeting all the needs in our family (and sometimes beyond). It was too much. Most people would have admitted their limits, but not me! I kept trying to carry on as if nothing were wrong. And on the outside, it all looked pretty consistent. But within our family, relationships were breaking down just as surely as my body was. Still, in my stubbornness and pride I refused to admit that I was less than perfect and needed help.

God is patient; he is the very definition of patience. But when his children refuse to humble themselves, he will do what it takes to bring them to a place of surrender. In April of 2015, I suffered a massive hemorrhage. I languished in the emergency room for five hours before a doctor even assessed my actual situation and determined I was critical enough to need immediate surgery. It was another two hours before my surgery was complete and I was in recovery. Before the ordeal was over, I had lost two liters of blood—just under half my body's total amount. For the next few weeks I was basically bedridden. It took a full year before I had enough energy and strength to do all the activities I'd done before the emergency.

I'd had other health crises before, but it was this one which forced me to admit I *can't* do it all. In fact, most days I could do only one thing. I could clean the bathrooms *or* take a short bike ride with my kids, but not both. When the chosen activity was done, I spent the rest of the day on the couch with barely enough energy to focus on homeschooling. It forced me to humble myself, to give up my insistence on doing everything. It forced me to ask for and allow others to help me.

I still don't convalesce well. I have to really work at letting go and allowing others to step in and help. And when I'm perfectly healthy, I definitely don't like sitting still and doing nothing! It takes concentrated effort on my part to set aside my "to do" list, to be present in the moment, and to allow myself to freely enjoy relaxation. It's a healthy and necessary struggle though.

We all need rest. We all need help. We all need to accept our limits. It is a part of letting God write the story instead of dictating it ourselves. If you tend toward over-activity, make a plan and ask for accountability. I've found both of these strategies to be effective. Having someone call me out when I'm overdoing it helps me keep my goals and progress in perspective. Making a plan for how much I want to accomplish *as well as* how I'm going to rest, frees me up to work hard but then let go and relax, receiving the rest and restoration my body and mind require. Rest in God's ability to write a beautiful story, and remember—you're not the author; you're just along for the ride!

Truth from God's Word

God has given us power to defeat the Enemy both in our minds and our hearts. Take some time to read and meditate on these Scriptures:

- ❖ Psalms 131
- ❖ Proverbs 16:3
- ❖ Ecclesiastes 4:9-12
- ❖ Jeremiah 17:7-8
- ❖ John 15:4-5
- ❖ 2 Corinthians 9:8
- ❖ 2 Corinthians 12:9-10
- ❖ Hebrews 4:9-11
- ❖ 1 Peter 1:13-25a
- ❖ 2 Peter 1:3-4

The Story's Conflict

(Lies about Failures)

*Too often real or supposed failures compound my
sense of worthlessness and rob me of joy and hope.*

Every good story has some conflict. There is an antagonist
(or two or three) trying to thwart every hero's success.
Sometimes the antagonist is a person—Lord Voldemort,
Cruella de Vil; sometimes it's a project to conquer—a great
white whale, an unforgiving mountain; and sometimes it's
something deeper and closer to home—a personal demon
named Mr. Hyde, an all-consuming guilt that resounds as a
telltale heartbeat.

Similarly, in each of our stories there is at least one
Antagonist—our ancient accuser the devil—who sets him-
self up to steal, kill, and destroy. In addition, almost every
fictional hero comes to a point in the story where his or her
own doubts, weaknesses, and failures become an obstacle

threatening the ultimate success of the journey. This is no less true in our real life stories.

By now you know what a perfectionist I am. (I say *am* because I still struggle with this every single day.) Much of this striving for perfection has ended in destructive outcomes in my life, but there were some particularly spectacular crash and burn scenes along the way. These were failures of epic proportion—at least in my own estimation. And each and every one of these failures, whether real or supposed, compounded my sense of worthlessness and robbed me of my joy and hope.

I have always been harder on myself than I am on others. Granted, I have high expectations for *everyone*. I'm one of those people who is a stickler for rules (at least until my inner rebel kicks in), and I expect everyone to toe the line and meet the standard. But I do tend to have a little more grace for others' mistakes. When it comes to my own mistakes? Well, I don't have much grace at all.

I don't know why. Perhaps it's because I know I *could* have met the standard (or at least I expect I could have). In any case, I have a hard time letting my failures go. I am daily aware of my shortcomings, and I have a running account in the back of my mind of all the ways I've failed. Even when I try to turn this inventory off, it never fully goes away.

Though this is still a constant struggle for me, I'm much better off than I used to be thanks to the grace of God. A few years ago our pastors made the decision to preach through the book of Romans and to stick with it for as long as it took to cover the epistle thoroughly. I think our church parked on Romans for two years, maybe longer. Some people grumbled about this, but I am so thankful we did!

I'm thick headed. God usually has to hit me over the head with a proverbial two-by-four for me to learn whatever lesson He's trying to teach me. When we first started studying and memorizing Romans, I was immediately struck by the theme of grace. It was exactly what I needed to hear at that point in

my life, but I'm not sure it would have impacted me so profoundly if our pastors had taught a tidy eight sermon series. I needed to hear the message of grace again and again…and then again. Those years were the turning point in my life, the beginning of my healing and my transition.

Failure in and of itself is not bad. Many highly successful people have failure in their history. The difference is they know how to use failure as a springboard for success. They learn from their failures and grow stronger. This is the view of the cross. God takes our failures and transforms them into something altogether different. Through the lens of grace, failures become the means by which God can minister through us to a hurting world.

> *Through the lens of grace, failures become the means by which God can minister through us to a hurting world.*

Unfortunately, the Antagonist knows our weaknesses well. He seeks to derail our vision, motivation, and hope, and he uses failure as a great demoralizer. With it he diminishes us, limits us, and convinces us to give up. His end goal is to make failure the last chapter in your story and in mine.

He's effective at this kind of lie—a master at making it feel like the story has gone very wrong and there's no getting it back on track. When this occurs, depression and hopelessness can set in, threatening relationships, callings, even life itself. The lies in this section focus on these hope robbers.

Lie Number Eleven: My past mistakes define who I am and who I can become.

I hopped out of the car, laughing at a joke my friends were sharing. It had been a great night. We'd been to the movies and then for ice cream. Finally, we'd spent the last hour just talking and laughing in the picnic shelter of a local park where I'd been snuggled in my boyfriend's arms to ward off the

night's chill. Now, I stopped on my front step before opening the door. I had to take off the gold bracelet with the words "I Love You" inscribed on them. I didn't want my parents to see that bracelet and know I was dating him.

In high school, I made the choice to date a guy who did not share my Christian beliefs. This went against my all convictions, and in a very real sense I was rebelling against God. I also hid the relationship from my parents, lying in order to cover up what I was doing. The relationship turned out to be toxic. It was far more physical than I wanted it to be, and the secretive nature of it, along with my cavalier attitude towards God, wreaked havoc on my soul.

The reality is the relationship was based on a previous lie—I have to fit in to be accepted. In my immature teenage mind I was sure nothing would prove my acceptance more than having a boyfriend. If a guy thought I was attractive enough (both physically and socially), it would confirm my value and prove I was, indeed, accepted. So I prayed for a boyfriend.

Looking back now I am embarrassed at this request, but at the time I was earnest. The trouble with prayers of this nature is God is not in the business of reinforcing our misconceptions. And since he knows our hearts even better than we know them, He knows the secret intents underlying every request. He knows answering a prayer which is based in fear, lust, anger, greed, or a lack of trust will only enable that sin. And God loves us too much to allow sin to go unmediated in our lives.

Of course, I didn't know any of this at the time. All I knew was that God wasn't answering my prayers the way I wanted him to. It made me frustrated and angry. What good did it do me to obey God if I was no better off than my unsaved friends? Wasn't the Christian life supposed to be full of blessings? It would be years before God could even begin to address these

misconceptions, but we'll discuss them later. Suffice it to say, it led to a heart ripe for rebellion.

So when a cute boy in my classes asked if I would go out with him, I wrestled with the decision for a day or two then outright told God, "You're clearly not going to give me my heart's desire. I know dating this guy is wrong because he's not a Christian, but I don't care. I'm going to do it anyway."

The moment I told God, "I'm going to do it anyway," I felt a change in my relationship with him. It started small—a twinge of guilt for having defied God which became a nagging guilt for living a double life. Then I found myself buried in the pressure to keep up my Christian image while living something totally different away from home and church.

Not only this, but my relationship with the Lord broke down. I couldn't read the Bible, because every time I opened it up I read something convicting—no doubt the Holy Spirit was after me! Then it got to the point where I couldn't pray. I would sit down at the piano and play and sing praise choruses just to feel some connection to God. Finally, I couldn't even sing. At church I would stand with the rest of the congregation and silently weep inside. Alone in my bed at night I would weep openly. The only thing I could say was, "Spirit, don't leave me. Spirit, don't leave me."

When I finally broke free, I was left with a ton of regrets. I regretted defying God. I regretted lying to my parents. I regretted how physical the relationship had been. I regretted the lost time my later-to-be husband and I could have had together as a couple in high school (another story altogether). These regrets had far reaching consequences well into my adult years, most notably in my marriage.

Jesus' death on the cross paid for that season of my life—each and every sin. But the Antagonist is crafty. He took what God designed as godly sorrow which leads to repentance and transformed it into the lie that I was now damaged goods. Yes, I believed I was forgiven. But I also

subconsciously believed I was now defined by this season of sin; I was somehow less in the kingdom of God, and my testimony was forever marred.

The reality is my testimony is still very much usable as far as God is concerned. In fact, his grace is *made apparent* by my shortcomings—as the apostle Paul said, *"...where sin increased, grace abounded all the more" (Romans 5:20b).* It was my perfect Christian image which was marred. Like the Pharisees, I cared more about what people saw and thought of me than about how God might want to use my life.

God can and does use our entire story! Like children who scribble in a book with a marker, sometimes our life choices scribble over what God is writing. But we have to remember nothing is outside of his providential will. Even our scribbles get incorporated into his larger picture. He can use them for his glory if we let him!

Truth from God's Word

God has given us power to defeat the Enemy both in our minds and our hearts. Take some time to read and meditate on these Scriptures:

- ❖ Psalms 51
- ❖ Isaiah 1:18
- ❖ Romans 5:1-11
- ❖ Romans 8:1-11
- ❖ 2 Corinthians 5:17-21
- ❖ Ephesians 2:8-10
- ❖ Philippians 1:6
- ❖ Colossians 1: 9-14
- ❖ Colossians 2:6-15
- ❖ 1 John 3:1-3

Lie Number Twelve: If my marriage or my kids don't turn out "right" it must be my fault.

I've gone through some hard things in my life, and I've shared some of those in this book. But nothing could prepare me for the anguish I felt when we experienced a crisis with one of our children.

I would have loved to share that story with you, but when I asked my child permission to tell their story, they asked me not to. It felt a little too personal, a little too vulnerable to them. I get that. Sharing a shortcoming, a struggle, or a difficulty feels raw and exposed. I know because I've been there. Suffice it to say, a crisis of this magnitude is almost as excruciating for the parent as for the child. It feels helpless and hopeless.

This season of life was very difficult for our whole family. I remember walking the neighborhood one day, sobbing and praying. I was in a deep anguish like none I've known before or since. And if the gravity and agony of the situation wasn't enough, I also felt like it was *my* responsibility to fix things. It was a heavy burden to bear and prime soil for the devil to plant a lie—the one that said I was to blame. Surely someone this young couldn't experience such a crisis unless I, their mother, had failed them.

Not only was I certain I had failed them, but I could find a multitude of reasons why *all* of it was my fault. Maybe I hadn't trained their heart right when they were very young. Maybe I hadn't disciplined them enough. Maybe I'd disciplined too much. Perhaps I should never have spanked them. I had deep guilt over losing my temper and yelling at them. And on and on it went.

I don't know how long I walked that day, but eventually God got to my heart. He asked me if I was willing to trust him with this child. If I was willing to relinquish all control and ownership. I had to admit this child was never really mine to

begin with. They had been placed in my care, but they were ultimately God's child and God's responsibility. Yes, there were things I could be sorry and apologize for, but I could not take on the weight of the final choices of another person—even if that person was my own child. Just as I stand before God on the mercy of his love and grace, so too does every other member of my household.

Eventually we sought help from a pastor and from our family doctor. Slowly we regained the child we'd lost. I'd like to say everything is fine now and the struggles are all over, but it's not true. We're still working on mending broken relationships and building up healthier patterns of relating. Some days are hard, and we all continue to fail from time to time.

I still pray every day for each of my children, but I have come to a place of trust. God has each of their highest good in mind. My children may not always do things the way I would or make the choices I would make, but ultimately they have to choose for themselves. I cannot choose for them. They may at some point in the future make a big mess of their lives. But it won't be my fault, nor will it be my responsibility to fix it. They'll have to turn to God and let him do the rewrites. After all, He's the Author of each of their stories too.

If you live with the lie that you are somehow responsible for the way your spouse or your children behave, please remember each and every person has a free will. Each chooses his or her own actions. Circumstances and other factors play a part, to be sure, but you cannot shoulder the blame when someone else does wrong, nor can you take responsibility if someone chooses to walk away from God. You can love them. You can pray for them. You can even try to steer them in the way they should go. But eventually you have to release them to God.

Remember, God is the best Author they could have. He's committed to making their lives Masterpieces too.

Truth from God's Word

God has given us power to defeat the Enemy both in our minds and our hearts. Take some time to read and meditate on these Scriptures:

- ❖ Ezekiel 18:20-23
- ❖ Ezekiel 34:11-17, 22
- ❖ Luke 6:43-45
- ❖ John 6:35-40
- ❖ Romans 8:28-30
- ❖ Romans 9:15-33
- ❖ Romans 14:4, 7-13
- ❖ Romans 15:1-7
- ❖ 1 Corinthians 3:12-15
- ❖ Galatians 6:1-10
- ❖ Ephesians 1:4-14
- ❖ Colossians 3:18-21, 23-25
- ❖ 2 Timothy 2:19
- ❖ James 4:11-12

Lie Number Thirteen: I can avoid failure by following the perfect formula.

I sat in the auditorium eagerly scanning the workshop program. So many choices, and they all seemed so appealing:

- Capturing Your Child's Heart
- Helping Siblings Get Along
- How to Make Math Fun
- Raising Sons for the Kingdom of God
- 10 Proven Strategies for No Tears Learning

For many years, the annual homeschooling conference was one of the highlights of my year—encouragement, inspiration,

curriculum shopping, and a break from my kids! What was not to love? So much good was cultivated in my life, my marriage, my parenting, and my homeschooling at these conferences. And yet, this annual "shot in the arm" also unwittingly reinforced a lie I had bought into—I can avoid failure by following the right formula.

Speaker after speaker and curriculum rep after curriculum rep all seemed to shore up the notion that homeschooling would create perfect kids and a perfect family. Everything I read and everything I heard touted homeschooling as a foolproof route to respectful and exceptionally intelligent children who would turn out "right," a united marriage, a close-knit family, et cetera, et cetera. The only trouble is…there is no magic formula. I had to learn this the hard way.

I began homeschooling for a number of reasons and have continued it for twenty years (and counting!) for even more reasons. It *has* been successful in many ways. But it certainly didn't solve all our family's problems. It fact, it even *created* some problems for us. And as I like to tell people half-jokingly: homeschooling brings out the worst in everybody.

Being together 24/7—living, working, learning—has a way of revealing sin nature. It's hard to hide your sin when you're together all the time. And so, just like everyone else, we dealt with laziness, procrastination, bickering, bossiness, selfishness, anger, jealousy, disrespect, and disobedience, just to name a few—and those not just from the kids! Problems that were brewing under the surface did not magically go away because we were a "homeschooling family." The magic formula wasn't so magic after all.

Homeschooling was no guarantee when it came to learning either. And though I still tell moms new to the journey that it is hard to mess homeschooling up, I also know firsthand that it just doesn't work for some kids or some families. In our own family, while learning came easily for two of our children, the other two struggled with all kinds of learning

issues: dyslexia, dyscalculia, ADD, and Sensory Integration Disorder. We were able to create coping strategies for one of our children, but the other floundered.

Eventually, we had to admit homeschooling had failed that child and turn to classroom instruction. Did I as the homeschool teacher feel like a failure? Yes! But at that point I was ready to ditch the formula and find freedom, so it was also a relief to give up the charade and get the help we needed.

It is tempting to try and find the one thing that will eliminate failure from our lives, to think *"If I just follow this formula, I can't fail."* But that's simply not true. It doesn't matter if it's homeschooling or church attendance or the "right" way to date or any other program, habit, or belief you can put in the blank—nothing is a guarantee that things will turn out the way you want them to. Why? Because you and I and all the other characters in our stories are broken people. None of us is perfect. We all get it wrong sometimes—a lot of the time, if we're honest. It's a part of being human.

If we are trusting a program, habit, practice, or any other formula for perfection, then we have created a false god. We are looking to that *thing* to save us rather than God himself. We have to come to terms with our humanity—our brokenness.

So how *should* we handle the failure? If you're like me, you might be tempted to try to fix the problem, to eliminate the blot on that page of your life. The trouble is, many failures cannot be "fixed," and none can be erased completely. Attempting to make up for your mistakes can even lead to bigger problems which need fixing. It's an unending labyrinth of trying and failing.

When fixing the problem doesn't work, many of us fall into the trap of beating ourselves up for our mistakes. But berating yourself for your failures won't help the problem; it will only make you feel guilty and miserable!

If you've found yourself caught in this web of trusting false formulas, failing, attempting to fix the problems, and then

upbraiding yourself for your failures…STOP! God knows none of us is perfect; he loves us anyway. He does not require we get our act together before we have access to his love or grace. And grace is the only "formula" that works.

Failure in God's eyes is only a rough draft. The story isn't finished—God does rewrites! Do yourself a favor and give yourself the same kind of love and grace God has shown you. Failure is not an identity! It is an outcome of actions, not a state of being. Don't let the Antagonist tell you otherwise.

> *Failure is not an identity!*

Truth from God's Word

God has given us power to defeat the Enemy both in our minds and our hearts. Take some time to read and meditate on these Scriptures:

- ❖ Psalms 19:7-11
- ❖ Psalms 103:8-18
- ❖ Proverbs 2:1-11
- ❖ Proverbs 3:1-26
- ❖ John 15:1-11
- ❖ Romans 4:4-8
- ❖ Romans 5:6-8
- ❖ Romans 10:4
- ❖ Galatians 3:1-14
- ❖ Ephesians 2:4-10
- ❖ Hebrews 10:14-23

Lie Number Fourteen: I'll never change; I'm stuck with my failures.

By most people's standards I'm a good person. I am responsible and help out in my community. I'm nice to my neighbors

and work to get along with them. I "selflessly" take care of my family, and I'm a pretty good mom. I certainly have never committed any heinous crimes. But I consistently struggle with a few sins. No matter what I do, I can't seem to kick the temptations to gossip or covet; I can't overcome my tendencies toward pride and selfishness; I tell "white" lies; I lose my temper and yell at my family; I am critical of my husband.

Most people would dismiss these as common to the human race. Nobody's perfect. But I know God doesn't view sin lightly. He doesn't want me to callously live with my sin. His Spirit wants to bring about God's righteousness in my life. Over and over I repent and vow to change…but somehow I find myself failing again. Nowadays when these failures raise their ugly heads, I press into God's grace, but there was a time when I actually hated who I was. I even contemplated suicide.

This story actually starts years ago in college. Ashamed at my self-centeredness—my need for everyone to notice me and include me—I started fixating on all my negative attributes. I knew I struggled with pride, selfishness, and taking more from relationships than I gave, and I contrasted these struggles with what I wanted to be—humble, selfless, giving, and kind.

It wasn't long before I began to hate myself. I even had one moment at college where a suicidal thought popped into my head. I'd never even considered killing myself before, and I was horrified this would even enter my mind. I quickly readjusted some things in my life to eliminate this kind of thinking. But a self-loathing was rumbling under the surface nonetheless.

Throughout those college years and the early years of our marriage, my boyfriend turned fiancé turned husband loved me faithfully. He didn't seem phased by what I considered character flaws, and his steady love helped me accept myself… for the time being. But as my life complicated with children and responsibilities and health issues, I struggled more and more with attitudes and behaviors I found appalling. Most

notable was my anger. I would lose my temper at my kids and rage at them, yelling and even belittling to try and get them to do whatever it was I wanted them to do. At my very worst, I resorted to shaking or slapping one of my children who especially knew how to push my buttons.

Of course I didn't want to be this way, and it all fed into a guilt cycle. I was horrified and ashamed of my behavior. This was not the *real* me—the me I wanted to be—and I couldn't understand where this monster had come from. Furthermore, I felt like I *should* be able to control myself. A good Christian shouldn't struggle with these kinds of things, right? After all, the Holy Spirit lived inside of me and I had a changed nature, or so the Bible told me *(2 Cor. 5:17)*.

But if I had a new nature, I certainly wasn't seeing evidence of it in my life. My God-given nature appeared to be fighting a losing battle with my sinful flesh, which only made me feel more and more like a failure. I began to despair of *ever* being the kind of person I wanted to be. With increasing frequency I began to feel like my family would be better off without me. And I knew *I* would be better off dead. After all, I'd be in heaven with Jesus, free from the pain and the struggle, the guilt and the shame which plagued me day in and day out. So I contemplated suicide. As for my family, they saw the nastiness, but even they didn't know I was thinking about ending my own life.

My depression and thoughts of suicide were not a daily problem. Some days I was happy and grateful for my life. On the dark days I tried to remind myself of the blessings and the joys. But the dark days were frequent enough and the suicidal thoughts flitted in and out with enough regularity that I ended up seeking medical help.

Unfortunately, I was allergic to the medication I was put on, though we didn't know it for almost three years. I started blacking out for no apparent reason and having muscle control

issues. Every medical test came back negative. No one could figure out what was going on.

In my mind I was now even more of a burden to my family. And because there was no end in sight, my feelings of hopelessness increased. I had a mounting desire to leave this world behind. The only thing which stayed my hand was the fact that I didn't want my family to experience the trauma and pain of a suicide as well.

But one day while driving home, I realized if I were to drive headlong into one of the massive power poles lining our neighborhood, my death would look like an accident linked to my blacking out episodes. Suicide became a very real possibility for me. From that moment on the idea niggled around in the back of my mind.

Interestingly, I never once sought God with this inner anguish. I'd sought him before many a time, some days lying face down on my floor sobbing and crying out to him. But once the idea of suicide entered my brain, I stopped seeking God.

One day when I was feeling defeated, I found myself in the car alone. I realized this was my opportunity. If I were going to commit suicide, now was my chance. As I neared the power poles, I wrestled with whether or not this was really what I wanted to do. I knew I had only a few more seconds to decide, and in that desperate moment I cried out to God. Instantly, it was as if two giant hands firmly gripped my arms, and I heard an almost audible voice say, "I've got you." By then it was too late to complete the act, but I didn't want to kill myself anymore. I pulled over and cried and said, "Thank You, Jesus," over and over and over.

Satan, the Antagonist, wants you to believe you're stuck with your failures and you'll never change—it's hopeless. But as long as your heart is beating and there is breath in your lungs hope still exists! God is not in the business of trashing manuscripts. He has not given up on you, my friend. He will

keep on editing your story until it is exactly what he intends for it—for *you*—to be.

> *God began doing a good work in you, and I am sure he will continue it until it is finished...*

> *Philippians. 1:6, NCV*

Truth from God's Word

God has given us power to defeat the Enemy both in our minds and our hearts. Take some time to read and meditate on these Scriptures:

- ❖ Nehemiah 9:16-20
- ❖ Isaiah 43:18-19
- ❖ Micah 7:18-19
- ❖ Zechariah 3:1-4
- ❖ Romans 7:19-8:2
- ❖ Romans 10:11-12
- ❖ 2 Corinthians 3:17-4:1, 7-9
- ❖ 1 John 4:4

Lie Number Fifteen: I don't deserve God's forgiveness so I won't forgive myself.

I didn't even realize I'd bought into this particular lie until I was preparing to write this book!

For years my father had been telling me he thought I was harboring unforgiveness in my heart. A counselor for almost forty years now, he can often recognize when unforgiveness is at play in a person's life. Over and over throughout the years he mentioned this to me, and over and over I examined my heart and tried to figure out whom I wasn't forgiving. I forgave my mom; I forgave my high school boyfriend; I conjured up

people I might need to forgive and let them off the hook for any little thing I could come up with. But I never considered I might not be forgiving myself.

At one point my dad did mentioned this to me, and I had to admit maybe it was true, but I couldn't figure out what I wasn't forgiving myself for. I'd gone back through all my big sins and failures and attempted to walk through the steps of self-forgiveness, but somehow something was lingering. I couldn't figure out how to give myself a clean slate. Every time I tried to forgive myself, something inside me resisted.

The problem didn't dawn on me until I was pouring over my life and praying about which lies to include in this book. I consciously knew God's forgiven me—His grace is boundless—but my own sense of justice is so strong that subconsciously I wouldn't accept this free grace. Oh, I accepted God's grace for my *salvation,* but in my day-to-day living I chose to leave his grace on the table. I knew I didn't deserve this forgiveness, so if God wasn't going to require payment from me, I would require it of myself.

Even though Jesus' death on the cross satisfied God's righteous standard, *I* still saw that standard as unmet. I held it above my own head—an invisible banner marking me as surely as Hester's big red 'A' marked her in *The Scarlet Letter.* Even though God saw me as righteous through the blood of Jesus, I chose to see myself as a sinner, undeserving of God's grace.

I remember the moment the Holy Spirit brought this to light for me. It was a startling discovery. I sat stunned. Then I cried. I cried because not forgiving myself when the God of the universe had forgiven me was an affront to the sacrifice Jesus paid on the cross for my sins. It was like looking Jesus in the face and saying, "Thanks for dying for me, but I'm not going to take you up on your sacrificial offering of love." How ashamed I felt. And yet, the love and forgiveness and utter acceptance of God for me just as I am flooded over

me. Suddenly, I could forgive myself. I *had* to—how could I do otherwise?

I don't know if I'll ever struggle with this lie again, but for now I can look at myself and smile with genuine love and acceptance, something I haven't done for a long, long time. Maybe you also struggle to accept yourself. You've got a million reasons why you don't deserve God's love and forgiveness and grace—a list that looms in the background, tainting your relationship with God and others.

The fact of the matter is none of us deserves God's forgiveness. Still, he is merciful and gracious, offering us forgiveness anyway. It's time to look Jesus full in the face, see the acceptance in his loving eyes, and say, "Thank You for Your sacrifice. I accept it—fully."

Truth from God's Word

God has given us power to defeat the Enemy both in our minds and our hearts. Take some time to read and meditate on these Scriptures:

- ❖ Psalms 32
- ❖ Psalms 103:8-17
- ❖ Psalms 130
- ❖ Isaiah 43:25
- ❖ Lamentations 3:19-26
- ❖ Acts 3:19
- ❖ Colossians 2:13-15
- ❖ 1 John 2:1-2
- ❖ Revelation 3:19-21

The Story's Tone
(Lies about Expectations)

Too often my happiness is tied to my expectations of God, myself, others, and the things I feel entitled to.

The movie was a box office hit—the top grossing film in America that year and the second top grossing film worldwide. It was the movie everyone was talking about! And I hadn't seen it.

"Have you seen *Forrest Gump* yet?"

"No...don't tell me anything."

But of course they did.

"Oh my goodness, it was the best movie I've ever seen!"

And... *"It's so insightful."*

And... *"It gives you the big picture of the last several decades. You really get a sense for why things happened the way they did."*

And... *"Why haven't you seen this yet? You've got to see it!"*

I wanted to see it. And by the time everyone—professional reviewers to friends and family—were done singing its praises, I expected the best cinematic experience of my life!

Only I didn't like it. Not even a little bit.

It was slow moving. The characters were stereotypical tropes. The plot (what little there was) was boring. It did not shed light on history or the human race for me, and it certainly didn't inspire me. I felt let down.

Of course, *Forrest Gump* was only a movie. But there have been events, relationships, even whole seasons of my life which have been disappointments to me. Not only have I felt disappointed, I've also felt rejected, manipulated, and betrayed. These feelings are the fodder for lies. They occur when reality does not match up with our expectations.

When I have unrealistic expectations of others or myself or even God, I believe lies about what will make me happy, appreciated, satisfied, or fulfilled. Unrealistic expectations invariably lead to disappointment, anger, feelings of rejection, and a host of identity-shaping lies.

> *Unrealistic expectations invariably lead to... a host of identity-shaping lies.*

Most of us, whether we realize it or not, root our happiness in people and circumstances which can and will fail to meet our expectations. And though God never fails, our expectations of even him may be unfounded, leading to even greater disappointment.

The truth is, in Christ Jesus we have all the joy and purpose we will ever need:

...the hope to which he has called [us], the riches of his glorious inheritance in his holy people.

Ephesians 1:18b

The tone of *every* story God writes is one of hope. But we often confuse hope with ease and happiness. God never promised a life free of pain and suffering—in fact, the Bible is full of verses indicating the opposite is true—but he does promise everything will work for our ultimate good; an eternal future awaits us. This truth is the basis for our story's hopeful tone!

Unfortunately, we too often base our happiness and our idea of success on what can never truly deliver. When our expectations of God, others, our circumstances, or ourselves are skewed, we muddy the tone of the story. The lies in this section focus on some common unrealistic expectations.

Lie Number Sixteen: Everything would be better if 'XYZ.'

"Aimee, why don't you come out with the rest of us and enjoy the great outdoors?"

"No thank you; I'm perfectly happy in here."

Lying on my sleeping bag reading a book in the tent or camper while everyone else enjoys the view has been a reoccurring scenario in my life. There is often a breeze, which makes it just a bit chilly; not to mention the flies (or mosquitos or gnats)—the great outdoors hasn't always seemed so great to me!

I didn't grow up a nature aficionado. For one thing, my parents are not outdoor enthusiasts—strike one for loving nature. For another thing, I have severe allergies and asthma, making being active outside more of a chore than a pleasure—strike two for nature loving. Finally, I have a very narrow comfort zone (I both chill and overheat easily)—strike three for fostering any affection for the great outdoors. So when my husband and I first started dating, I required some perspective rewiring. His family loves working, playing, and relaxing outside. In fact, the first summer we dated, they spent nearly every weekend at the lake boating, swimming, and reveling in nature. It was

culture shock for a gal who had mostly stayed inside reading, baking, watching television, and playing board games.

Don't get me wrong! There was something exhilarating about finally discovering the joy of spending an entire weekend on the water, lazing around and getting sunbaked. But there was a lot about the whole experience I couldn't stand. I absolutely hate wind, and the reservoir we frequented is known for gusty afternoons. I detest outhouses, but it was pit toilets or the bushes. I'm also a bit of a clean freak, which meant gritty sand clinging to my entire body was practically beyond my endurance! I've since learned to deal with each of these inconveniences, but those first few years together challenged me more than I care to admit.

I remember sitting on the beach a few short weeks after we were married, feeling overwhelmed by all the elements I didn't like and letting my grouchy attitude spill out in my countenance and words. My mother-in-law knit her eyebrows together, looked long and hard at me, and said in a tone I've heard only rarely since, "You know, you'd have a lot more fun here if you'd just accept things the way they are and decide to enjoy this for what it is." Then she turned her back on me and focused on the beautiful vista.

I wasn't quite sure what to say or even what to think of this remonstrance. For one thing, my mother-in-law had never spoken in such a confrontational or direct way to me before. For that matter, neither had anyone else except for my parents. I was not used to having my pet peeves challenged. But she was right. I was notorious for thinking. "If only *this* were different, I'd be happier." This sentiment is the starting block to a whole host of expectation-based lies.

I was hurt and a little offended that day, but as I sat stewing over her words, I had to admit—changing my mindset *would* make me happier. Calling me out on my negative attitude was probably the best thing she could have done. It totally changed my attitude about the beach!

I wish I could say it altered my entire life's perspective, but I can't. My tendency toward having an "if this, then that" perspective continued. Too often I am convinced some elusive event or habit or change is the lynchpin to my happiness. My list of 'XYZ' has been numerous over the years:

- If my husband would only help more
- If my kids wouldn't fight
- If I my house were tidier
- If I could keep up with homeschooling (especially the grading!)
- If I could just get enough sleep
- If I didn't have to combat chronic health issues

I still struggle with this mentality. Maybe I always will. But I am learning that happiness really does depend on my attitude—my mindset.

Sometimes Christians confuse joy with happiness. They talk about the joy of the Lord as if it is something rosy, as if a life filled with this kind of joy has a shiny veneer. Certainly, true joy *can* bubble up out of us like a wellspring of life. It can make us smile and even laugh in spite of our circumstances. It can make us sing when the rest of the world would curse (consider Paul and Silas in Acts 16).

Joy which comes from God transcends our circumstances. It is a fruit of the Spirit cultivated in our lives as part of our sanctification. But having the joy of the Lord does not mean we will always be *happy*. Even Jesus was not always happy. He experienced sadness *(Jn. 11:35, Lk. 19:41)*, frustration *(Mt. 16:5-11)*, anger *(Mk. 3:5, Jn. 2:13-16)*, and even despair *(Mk. 14:32-42)*.

The truth is, while *joy* is a state of the heart, *happiness* is a state of the mind. It is something we choose with our own free will.

> *The truth is, while joy is a state of the heart, happiness is a state of the mind.*

85

Though most of us choose to let external circumstances determine our happiness, true happiness does not *have* to be dependent on factors outside our control. We can choose to be happy despite poverty, illness, relational turmoil, political instability, job uncertainty, or even acute suffering. Just as we can cultivate joy in our hearts (by focusing on the truths found in God's Word and seeking to walk in step with the Spirit), so too can we cultivate happiness in our minds. It is a matter of deciding to say, *"Despite 'XYZ,' I choose to be happy."*

When I got initial feedback on this book, one friend suggested I'd made this too simple. She has struggled with depression and felt that sometimes her feelings were simply outside of her control. I understand. Remember, I too have struggled with depression and even suicidal thoughts.[***] But this I do know—discontent breeds discontent! When we focus on what is negative—failures, disappointments, or unmet expectations—we fan that fire inside us that says, *"Life is no good unless...."*

But fire needs oxygen to burn. When we stop focusing on the negative, we stop fanning that flame. The fire's fuel—those shortcomings and disappointments—may still be there, but without the oxygen of our focus, that flame dies down.

In addition, we can combat that fire even more by pouring the water of positivity and God's truth on it. Reorienting our thinking quenches the flame and allows happiness to grow up over the burnt areas of our soul.

Focusing on what is good in our lives is one way to reorient our thinking. In fact, science has proven gratitude and positivity are powerful tools in reducing pain and stress and in increasing one's general feeling of happiness.[ii] This

[***] If you are experiencing depression and/or suicidal thoughts PLEASE consult a medical professional! There may be physiological or psychological imbalances that need to be addressed. A trained counselor or physician is better able to assess and address these needs than you can on your own in your depressed/suicidal state.

shouldn't surprise us. Over and over science confirms the validity of God's ways, and God has already told us to fix our minds on what is good and beautiful in our lives and in this world.

> *Finally, brothers and sisters, whatever is true, whatever is noble, whatever is right, whatever is pure, whatever is lovely, whatever is admirable—if anything is excellent or praiseworthy—think about such things.*

> *Philippians 4:8*

God intends the tone of your story to be one of hope and life, not just for you and your happiness, but for those around you as well. He wants to reach others through you, and a story with a positive tone reaches far more people than one that is morose. If you are sabotaging the tone of your story by having an if-then mentality, take time to cultivate more joy in your heart and more happiness in your mind!

Truth from God's Word

God has given us power to defeat the Enemy both in our minds and our hearts. Take some time to read and meditate on these Scriptures:

- ❖ Psalms 23
- ❖ Psalms 37
- ❖ Proverbs 4:20-27
- ❖ 2 Corinthians 9:8-11
- ❖ Philippians 3:7-14, 20-21
- ❖ Philippians 4:6-8
- ❖ Philippians 4:12-13, 19
- ❖ Colossians 3:1-5
- ❖ 2 Peter 1:2-11

Lie Number Seventeen: Other people have to meet my expectations of them in order for me to be happy.

"We need to talk."

My husband looked up from his laptop, uncertainty in his voice, "Okaaay?"

"If we don't change something, I'm afraid we're going to get a divorce."

It was clear the words had blindsided him. Which wasn't surprising considering we hadn't had any explosive fights or chilly silences. Just a long history of co-existing.

Companionable co-existing (with enough sex to keep the marriage alive) is fine with my husband. In his estimation, that's a *good* marriage. Getting along without fighting, staying faithful, raising the kids, and getting done what needs to be done are the stuff of marriage—of life.

But I'm an introspective, hopeless romantic. I'm forever digging deep, and I want my relationships to reflect those depths. I want to connect mentally, emotionally, and spiritually. I want to interact with others over social and political issues, over music and poetry and literature, over philosophy and theology. I want *soul* connection.

The night I confronted my husband we talked about a lot. Some things in our marriage needed to change. For starters, I promised him I wouldn't lie to him or hide things from him; I'd be open and transparent from that moment on. I've tried to stick to my promise.

But most of the changes were not as immediate. Many were slow in being worked out. (In fact, we're still working on them.) Some of the changes I wanted will probably never come to be. It's not that my husband is callous and uncaring; he simply *cannot* adequately give me what I'm craving. It is so foreign to his nature—how God designed *him*—it would be

like breathing water, which means he'd drown trying. It also means I've had to change what I expect of him.

Let me give you an example. My husband is a strong Christian, solidly devoted to serving God all the days of his life, but he has a hard time expressing his spiritual thoughts. Dissecting theological heavyweights (something which fires me up) is like pounding his head against a wall. If nothing else, it's going to give him a headache. So I've learned I need to seek my intense spiritual stimulation from others, be it Sunday school classes, Bible studies, or reading challenging theological books.

Releasing my husband from this expectation is better for both of us and for our marriage. Sometimes I forget and ask him for input he doesn't have. (Just the other day I asked him for help with something spiritual. I wanted concrete answers. He shook his head. "You know me," he said. "I don't even have quicksand answers.") Mostly, though, for the good of our marriage, I've learned to seek spiritual input elsewhere.

This is merely one example in our marriage; there are others. The same could be said for my children as well. If my happiness is tied to their attitudes, then the minute they start whining or bickering, I'm unhappy. If the tone of my day rests on how well they obey, what happens when I discover someone's room is still a disaster when I told them an hour ago to clean it up? Well, you know...my day is down the drain.

I'm sure you're getting the idea here, and I hope it's sparking some realization in your own mind. Where has your happiness and overall satisfaction with life been resting on others? It's important you root those expectations out now! Why? Because people will fail you.

Every single person in your life is going to fail at some point to live up to your expectations of them—probably repeatedly. And if your well-being hinges on how well they live up to those expectations, you're in for a bumpy ride at best and a crash and burn at worst! Do yourself and those you love a favor and release them from the expectations you've been holding over

them. Put those expectations on God instead, where true joy and fulfillment and purpose are found.

Truth from God's Word

God has given us power to defeat the Enemy both in our minds and our hearts. Take some time to read and meditate on these Scriptures:

- ❖ Matthew 6:14-15
- ❖ Matthew 7:1-5, 12
- ❖ Matthew 18:21-22
- ❖ Luke 6:27-38
- ❖ Galatians 5:13-18, 22-26
- ❖ Ephesians 4:31-5:2
- ❖ Ephesians 5:21-6:9
- ❖ Colossians 3:12-15

Lie Number Eighteen: I am entitled to 'XYZ.'

"I'm joining Bible Study Fellowship this fall; do you want to come with me?"

My shoulders slumped. "I can't; I have to homeschool."

I hung up the phone knowing I'd done the right thing, but the more I thought about it, the angrier I became. Here I was doing what God had called me to do, and I had had to give up everything—*everything*—I'd previously found pleasure in, including studying God's Word! At least that's the way it seemed to me.

I've been homeschooling for twenty years now, but I remember when my daughter was in Kindergarten and we first settled down into a rhythm of discipline and daily structure. Prior to this I had experienced the freedom of being a stay-at-home mother of preschoolers.

Now, don't get me wrong, being a stay-at-home mom is a fulltime job—and an exhausting one at that! And there *are* schedules to follow, especially when babies and toddlers are involved. But there is still a great measure of flexibility. Some days you can lounge around in your PJ's, scrolling social media while the kids smoosh their chubby little fingers through playdough. Other days you can stock the diaper bag, load up the stroller, and head to the park to play in the fresh air and sunshine. Still other days you can meet up with friends, allowing the kids to play while you sip coffee and chat. No two days have to look alike—there is freedom and variety.

Homeschooling changed all that for me. I was responsible for my daughter's academic education, and I couldn't shirk my responsibility. Suddenly, I had to be self-disciplined; I had to have a plan and stick to it. This was harder than I'd expected, though. I had a baby and a preschooler in the house as well, and they did not make schooling easy. Most days I had to resort to using their naptime to teach reading and math, which meant I no longer had naptime to myself for devotions, reading, a quick nap, or chore catch up.

In addition, I gave up some of the activities I'd loved and looked forward to each week—MOPS (Mothers of Preschoolers) and ladies' Bible study. I began to feel disconnected and isolated, and I resented it. Didn't I *deserve* some social interaction? Didn't I deserve some me-time? After all, being a full-time mom is hard, and being a homeschooling mom is even harder. I felt entitled to the luxuries I'd enjoyed before, and I wasn't going to let them go without a fight.

This is a rather simple example, but it illustrates a greater malady many in America suffer—the "I deserve" mentality. Somehow we have this idea we are entitled to any number of privileges and luxuries much of the world will never know. We feel we deserve to be healthy, pain free, and economically well off; we deserve to have rosy relationships; we deserve to have

down-time, me-time, and recreation; we deserve to experience comfort and ease.

...this notion of entitlement is rooted in pride. Though much of the Western world joins us in this mindset, I would argue Americans are the champions of this entitlement mentality, and I suffer from this malaise as much as the next person.

There's no other way around it; this notion of entitlement is rooted in pride. James 4:6 tells us, "God *opposes* the proud." That's a pretty strong statement. When we operate from a mentality rooted in pride, we are all but guaranteeing our own failure! I don't know about you, but I definitely don't want to have God opposing me.

The opposite of pride is humility, meekness, and a right understanding of our place in God's kingdom—beloved, redeemed, and righteous in our Father's eyes...but no more deserving than any other child of God. Even Jesus knew his place.

> *...though he was in the form of God, [he] did not count equality with God a thing to be grasped.*
>
> *Philippians 2:6, ESV*

Instead he lived from a place of humility; he served. And though he certainly deserved—more than anyone—a life of riches and luxury, political clout, prominent relationships, and relaxation, he chose instead a life of poverty, marginalization, exhaustion, betrayal, and suffering.

Thinking we *deserve* anything is a misinformed belief. All things good and pleasant in our lives are blessings bestowed by God out of his goodness and generosity—not anything we've earned or deserve. What we regard as difficulties are opportunities to exercise faith and trust in God, to practice dependence on him, and to live out the Gospel with

grace and humility. As followers of Jesus, we should expect nothing less.

Truth from God's Word

God has given us power to defeat the Enemy both in our minds and our hearts. Take some time to read and meditate on these Scriptures:

- ❖ Proverbs 8:10-11
- ❖ Habakkuk 3:17-19
- ❖ Mark 10:17-31
- ❖ Luke 12:15-34
- ❖ 2 Corinthians 6:3-10
- ❖ Philippians 3:7-21
- ❖ 1 Timothy 6:6-12, 17-19
- ❖ 1 John 2:15-17

Lie Number Nineteen: Because I'm a Christian I shouldn't have to suffer.

C.S. Lewis, Mother Theresa, Charles Spurgeon, Johnathan Livingstone, Florence Nightingale, and Fanny Crosby—all of these famous Christians share one thing in common: they suffered from physical and/or mental maladies. People we remember as giants of the faith saw themselves as weak, dependent wholly on God. Some even struggled with being dependent and, instead, doubted God's goodness and questioned their own faith.

I have always loved reading rich literature to my children. We started with beautiful picture books when they were young and progressed to novels, biographies, and narrative non-fiction. The year my oldest was in third grade I discovered a set of biographies highlighting the lives of Christian missionaries.[iii] These books not only provided my children with

godly role models, they ended up challenging and encouraging my own faith as well!

As we read these biographies of godly men and women who had devoted their lives to the spread of the Gospel, a theme began to emerge—suffering. It didn't look the same in every story, but each and every individual encountered some form of adversity. Some experienced it acutely in the form of extreme tragedy—persecution, torture, or martyrdom. For others it was ongoing. Some had health problems which served as a constant reminder of their frailty and dependence on God; for others it was a mental, emotional, or relational issue that trickled through life, surfacing every now and then like a small stream of bitter groundwater. But no matter what form it took, this suffering was significant in the lives and ministries of these servants of God.

This surprised me. Yes, I'd previously heard some dramatic stories—Corrie ten Boom's experiences in a Nazi concentration camp, or Jim Elliot's death at the hands of a native tribe in Ecuador—but I had not known of the less startling but still difficult trials of so many others. Story after story recounted painful childhoods, health problems, struggles with depression, poverty, and countless other hardships. It was as if suffering were part and parcel of being a missionary.

As this thread of suffering emerged, I began to question why. Why would God allow such affliction and anguish for so many of his faithful? Didn't they, of all people, deserve his blessings? It was here my thinking was faulty on two points. First, I assumed devotion and service to God somehow equated to greater spiritual and physical entitlement—*"the more dues I pay the more blessings I get"* kind of mentality. Second, I failed to understand that by allowing them to suffer, God *was* blessing them.

At this point you may be thinking, *"This woman is crazy! Suffering is not a blessing!"* And my own logical brain would agree with you. The brokenness of this world is demoralizing.

But God's ways are not our ways. He is infinitely wiser than we can ever imagine. None of the struggles and suffering we experience in life negate the fact that God *is* good, and that believers *are* blessed. The blessings of God often come in wrappings we don't recognize.

One of my favorite songs is *Blessings* by Laura Story. (If you haven't heard it, I highly recommend going to YouTube to listen to it!) In it she recounts all the blessings we routinely pray for—peace, comfort, protection, healing, prosperity, and relief from suffering. But the song goes on to say that, though God hears all these prayers, he loves us too much to give us what we're asking for. What if God actually brings blessing and healing into our lives through the very trials we're seeking to avoid? The song ends with:

What if my greatest disappointments,
Or the aching of this life,
Is the revealing of a greater thirst this world can't satisfy.
What if trials of this life,
The rain, the storms, the hardest nights
Are Your mercies in disguise[iv]

Over and over the Bible speaks of suffering. If there is anything we are guaranteed in this life, it's that we will suffer, and not simply because we live in a broken world, though that's certainly true. No, we are told we will suffer precisely *because* we are Christians *(Jn. 15:18-19, 2 Tim. 3:12)*!

Some of this suffering may be clearly tied to our faith, such as persecution, but over the years God has been showing me that he allows suffering of various kinds in our lives as a means to *bless* us. This blessing is two-fold. First, when we suffer, we share in the sufferings of Christ which results in being rewarded by God. This reward is future and eternal, awaiting us in heaven. It's going to be glorious! But the second aspect of God blessing us in and through our suffering is in being

comforted by God, in knowing him more, and in becoming more like him.

I know in my own life it often takes pain to drive me to God. When everything is going well, I am pretty independent. I feel I can do life on my own, and I forget to seek him. But God is the source of all that is good. He is the source of true life and satisfaction. Without him I cannot experience true joy, true peace, or true fulfillment. Hardship helps me remember this.

When my best laid plans fail, I remember I can't do it on my own, and I seek my Father's help. When this world is less than perfect—when it is, in fact, contributing to my sorrow, frustration, worry, or fear—I remember God is the source of my strength, confidence, peace, and joy, and I seek his face.

> *...God uses the trials of this world to drive us to what will ultimately bless us—himself.*

Like a mother who makes her child swallow the medicine because she knows it will ultimately be the thing that brings relief and health, so too God uses the trials of this world to drive us to what will ultimately bless us—himself.

Someday we will be free from pain and suffering, and all our tears will be wiped away. But for now, let us remember our commitment to follow Jesus does not ensure a life free from struggles and trials. Instead, those trials *"are achieving for us an eternal glory that far outweighs them all" (2 Cor. 4:17)*!

Truth from God's Word

God has given us power to defeat the Enemy both in our minds and our hearts. Take some time to read and meditate on these Scriptures:

- ❖ John 16:33
- ❖ Romans 8:16-18
- ❖ 2 Corinthians 1:3-11
- ❖ 2 Corinthians 4:7-18
- ❖ Hebrews 5:7-9
- ❖ Hebrews 11:32-39
- ❖ James 1:2-4, 12
- ❖ 1 Peter 2:19-21
- ❖ 1 Peter 3:14-17
- ❖ 1 Peter 4:12-19
- ❖ 1 Peter 5:7-11

Lie Number Twenty: I can control my life's outcome.

"By myself!"

My mother likes to tell people these were some of my first words. She regales people with stories of me as a toddler, stamping my foot and demanding my parents step out of the way and let me handle the situation. Apparently, I've been a control freak my whole life!

It might be cute to imagine two-year-old me resolutely putting my parents in their place, so to speak, but the reality is this stance is no laughing matter. It is not merely about controlling what I wear (two-year-old me) or my GPA (high-school me) or the color of our living room walls (grown-up me). It goes much deeper. My lifelong perfectionism and obsession with control has always ultimately been about this: I want to determine the outcome of my life. It is the ugly truth that undergirds all the lies in this section.

The reality is, most of us want this. We want happiness, ease, luxury, and fulfillment. We want a story with a happy ending. Our natural tendency is to grasp for control in order to ensure we get what we want. But we *don't* have control. We *can't* guarantee life will turn out the way we want.

In the middle of writing this book, the global health crisis of 2020 hit. Life as we know it ceased to exist. Stores, restaurants, schools, and churches closed. Basic food and hygiene items became unavailable. People the world over were relegated to staying within the four walls of their homes—working, living, surviving. It was scary for many and uncertain for all, and it brought into sharp focus the fact that none of us really knows what tomorrow will bring.

We don't really have control over anything. Like ramming sticks into a fan, this world has a way of throwing debris our direction which jams up our lives. Sometimes those proverbial sticks are big—divorce, the loss of a job, the death of a loved one—and sometimes they are smaller—a totaled car, a sick babysitter, a disobedient child. But big or little, these trials threaten our well laid plans and, thus, our security. When this happens, our gut reaction is to clench tighter to any semblance of control. After all, if we don't look out for our own interests, who will?

But by God's design, and contrary to our natural inclination, we find true peace only in surrender. That's because God is the only one who has any real power to affect the outcome. Only by releasing our grasp on our lives and surrendering to him do we ensure the happy ending we want.

Now, lest you roll your eyes and toss this book aside as being merely spiritual platitudes, let me say true surrender is not easy. Few actually achieve it. Personally, I have barely scratched the surface of what this means, but I do know it is something to aim for. Something to remind myself of each and every day.

Last year one of our pastors taught a class on being discipled by God. It was full of insight and wisdom—a lifetime of "nuggets" to mull over and apply. One of the things he gave

us was a laminated card containing three truths we were to memorize and remind ourselves of every day. One of these truths was: "God is with me and for me—now and always."

I really struggled with this truth, primarily because it intersects my issue of control. In order to fully surrender to God, I have to believe he devotedly loves me and has my best interest in mind. If I doubt this in any way, I will maintain a grip on my life. But as soon as I *truly* internalize this truth, I can relinquish control. Why? Because the moment I fully understand God's love for me and believe his purposes for me are good is the moment I also understand my future is far more secure in his hands than in mine.

I can't make you understand this truth. You're going to have to wrestle with God and come to this conclusion on your own. But until you do, you'll be fighting God for your storyline. Perhaps you need to do as I did and post that little phrase on your bathroom mirror (or at your desk, or in your car, or wherever you'll see it most): "God is with me and for me—now and always."

Truth from God's Word

God has given us power to defeat the Enemy both in our minds and our hearts. Take some time to read and meditate on these Scriptures:

- ❖ Job 23: 8-13
- ❖ Psalms 39:4-7
- ❖ Proverbs 3:5-10
- ❖ Isaiah 43:6-13
- ❖ Jeremiah 18:1-10
- ❖ Matthew 5:33-37
- ❖ Matthew 6:25-34
- ❖ Matthew 7:7-11
- ❖ James 4:13-16

The Story's Point of View

(Lies about Our View of God)

*If I have a flawed understanding of who
God is, I cannot grasp who I truly am.*

On March 14, 2020 at four o'clock in the afternoon, we got an email stating our public library would be closing at five o'clock that evening until further notice due to the global health crisis. It was utter pandemonium in our house!

I should pause here to say we have several avid readers in our home and we homeschool, so our use of the public library is higher than the average citizen. We frequent the library several times a week for school resources as well as books, audiobooks, and movies for pleasure. The library closure seemed like more of an emergency at the time than a virus we knew little about.

I've never seen our family decide something so quickly! Within a couple of minutes we had our shoes on and were out the door. Thankfully, we live only five minutes from our

favorite branch of the local library. We got there in time to do a whirlwind sweep of the building, grabbing armloads of books, movies, and audiobooks, including one I had put on hold.

It wasn't until a few days later when I was done with my current audiobook and was ready to start another that I discovered the Playaway (a palm-sized audiobook device) I'd checked out was not the one I'd been waiting to hear. The case had a depiction of the right book cover, but when I started listening to the story nothing made sense. This was a ghost story, certainly not the fantasy I thought I was getting! The trouble was, I was now stuck with the unexpected selection (for three months it turned out), and I don't even like ghost stories! It was a big disappointment.

It's a funny story, but it illustrates perfectly the disappointment we experience when we have a flawed understanding of God. When we don't properly understand who God is, what he does, and what he expects of us, it skews our perception of him.

If we view God as a distant deity who created the world but is largely uninvolved, we will diminish the role God seeks to have in our lives, living in a kind of spiritual indifference and missing the blessing of truly knowing our Savior.

If we primarily see God as a stern military drill sergeant waiting to punish us when we slip up, we'll never properly understand God's grace, and we'll live in fear of a God who loves us.

If we see God as a genie in a bottle who can grant us our deepest wishes, then when God doesn't answer our prayers and our lives don't go the way we want, we'll doubt his goodness and will live in disappointment and cynicism.

Finally, if we see God as a father but one who plays favorites, we may strive to earn his favor by living out a form of religion devoid of the tender relationship God desires to have with us, or we'll resent both the God who blesses and those who appear to be in his favor, hardening our hearts and living in envy and ingratitude.

All of these viewpoints are erroneous. God both demands holiness *and* freely bestows grace. He loves tenderly but is ready to discipline us when needed. He is mercy *and* justice, gentleness *and* power. He is not either or; he is both and—more complex than we can ever imagine.

It is our flawed understanding of who God is which causes us to imagine our standing with him as something other than it is. I know because I've battled more than one false perspective of God. I've struggled under a burden of false shame—assuming God is mad at me or loves me less because of my sin. I have been cynical and full of doubt because I've had the false assumption God should serve me rather than the other way around. I've wrestled with pride because I've placed my worth above others, viewing as entitlements those things which are only blessings. And I've felt the sting of false rejection when circumstances made it seem as if God loved someone else more than he loved me.

Ultimately, our worth comes from God, and our identity and happiness should be rooted in who *he* says we are and in the gospel—the message of his mercy and grace for us. But a skewed understanding of God (and his grace) means we *cannot* grasp who we truly are; we *cannot* comprehend the identity we have in him. It's as if, like the audiobook I got from the library, the story and the cover don't match. The lies featured in this section focus on misconceptions of who God is and what he does or doesn't do.

Lie Number Twenty-one: God loves me more when I do 'XYZ.'

When I get to Heaven gonna walk all around;
* have everlasting life.*
Gonna sit by my Savior, gonna put on my crown;
* have everlasting life...*

If you grew up in the church like I did, you were probably told at some point during your Sunday school years about the crown God was going to give you when you got to Heaven, and how you could earn jewels in your crown by doing good things. It painted a wonderful picture in my little mind, as it has for generations and probably will continue to do until Christ returns. But I think it also may have set me up to believe a lie about God and my standing with him.

Certainly, a future crown to be bestowed on us is mentioned several times in the New Testament *(1 Cor. 9:25; 2 Tim. 4:8; Jm. 1:12; 1 Pet. 5:4; Rev. 2:10)*, as is the doctrine of being rewarded for what we do and the heart attitudes we have *(Mt. 5:11-12, 6:1-6, 10:40-42, 16:27; 1 Cor. 3:8, 12-14; Rev. 19:7-8, 22:12)*. And though those crowns will ultimately be thrown down before the throne of God *(Rev. 4:10-11)*, I still think too many of us strive to earn God's love and approval. This is a trap our Antagonist sets for us. Like a bad choose-your-own-adventure book, he wants us wandering around in our stories, trying to get the best ending but always ending up defeated.

Before we discuss this further, it is important to note we can in no way earn a righteous standing before God. Our salvation is dependent solely on what Jesus did for us on the cross, paying the penalty we owed because of our sin and satisfying God's requirement of a perfect sacrifice. Nor does God love us more if we live godly lives. He loves us because he *is* love, and each of us is precious in his eyes.

His love for us is not dependent on how well we live up to his standard of holiness. However, we *can* please God *(Ps. 147:10-11; Rom. 8:8; 2 Cor. 5:9; 1 Thess. 2:4; Heb. 11:6, 13:16)*, or we can grieve him *(Gen. 6:5-6; Ps. 78:40; Is. 63:10; Eph. 4:30; Heb. 10:29)*.

This is such a tricky concept! I've struggled with this my whole life. I sincerely want to please God and do the things he has asked of his followers, but I have the tendency to mistake his *pleasure* with his love and acceptance. I know this problem is not unique to me. Many struggle with this lie. Why? Because as humans we tend to link *our* love and approval of someone to their words, attitudes, and actions. We struggle to love unconditionally. It is a concept foreign to us—at least in practice—even if we understand it in theory.

For years I walked around believing I could earn God's acceptance and approval by going to church, tithing, doing my devotions, or living more righteously than those around me. And when I failed, I was convinced God's view of me was diminished. Sometimes this was a conscious struggle, but more often than not it was something I assumed without even realizing it. Even now I must consciously work to combat this lie.

Maybe this is a struggle for you as well. Please believe me when I tell you God loves you! He loves you unconditionally. Unconditionally means without requirements, qualifications, or restrictions. It is a love that is unlimited, total, and absolute. There's no catch, no fine print, no strings attached. God is all in. He loves completely with no holds barred.

If you can't even imagine a love like this, you're not alone. I don't think any of us can truly comprehend this kind of love. But comprehend it or

There are no X's or Y's or Z's. You and I are loved. Period.

not, it is the love God directs toward us—like a firehose which knocks us down, or an ocean swell which overwhelms

us. In that ocean of love our inadequacies, our failures, our shame all drown. There are no X's or Y's or Z's. You and I are loved. Period.

Truth from God's Word

God has given us power to defeat the Enemy both in our minds and our hearts. Take some time to read and meditate on these Scriptures:

- ❖ Isaiah 43:1-7
- ❖ Matthew 10:29-31
- ❖ John 3:16-18
- ❖ Romans 4:4-5
- ❖ Romans 5:6-11
- ❖ Romans 8:29-39
- ❖ Ephesians 1:3-14
- ❖ Ephesians 2:1-10
- ❖ Colossians 1:13-14, 21-23a
- ❖ Titus 3:3-7

Lie Number Twenty-two: God has to do 'X' for me if I do 'Y' for him.

"God told me to give this to you."

I looked wary as he held a book out to me. Not because I didn't believe God might do such a thing, but because I didn't know this man; he was a chaperone for a different youth group also in attendance at the conference. But he insisted.

The bold yellow letters practically screamed at me from the cover—*Christ the Healer* (by F. F. Bosworth). I took the book and looked at him uncertainly.

"Read it," he said. And then as if to clarify, "You already have your healing; Jesus bought it for you on the cross. You just have to claim the healing that's already yours."

He proceeded to tell me a little more, flipping to a page of the thoroughly highlighted book to illustrate his point. "This healing is yours already," he emphasized. "Do you want to claim it? I'll join you in prayer right now."

I was still unconvinced but didn't feel I could say no. This man was the same age as my parents and clearly excited about his message, so I nodded and bowed my head. He placed his hand on my shoulder and prayed passionately then waited while I mumbled a short prayer. Before he left me, he encouraged me to write and date a claiming sentence in the front of the book—a kind of positive affirmation of things to come. I nodded mutely again and left, black book with glaring letters in hand.

Later I did write that sentence, and I did read the book. But I never saw the healing in my body. It was just one disappointment in a long line of disappointments surrounding my health, but an even bigger disappointment in God. One which reinforced a notion I already struggled with, that God was holding out on me. As the years progressed, I'd have many more disappointments like this until my heart became jaded and my trust in God's goodness waned.

I grew up in a church culture which emphasized abundant life in God—miracles, healings, and claiming material and physical prosperity. Verses supporting this were popular:

"Therefore I tell you, whatever you ask for in prayer, believe that you have received it, and it will be yours."

Mark 11:24

The trouble was, everybody else seemed to get what they believed for while I did not. My faith was shaken. Eventually, I became angry. My faulty thinking went something like this:

It's not like I'm asking God for a lot of riches. I just want healing in my body. Why won't God give me this good thing? Don't I deserve to be healed? After all, I love him and serve him faithfully. Why, compared to a lot of people I know, I am far and above a better person—a better Christian, even. If it is faith God wants, then I'm exerting as much faith as I can muster. Is it not enough? Does God love me less?

My whole concept of God and of the Christian life was backward. I was expecting God to do something for me in return for my service to him. I assumed there was a formula. In my case, it was healing in return for generally being a "good Christian," but this fallacy comes in many forms. Too often God's children expect:

- Financial prosperity in return for tithing or giving to missions
- A secure marriage in return for regular church attendance as a family
- Children who adhere to the faith in return for teaching Sunday school or homeschooling

The list goes on and on. Most Christians routinely assume, as I did, there is a formula—do 'XYZ' for God and voilà!... receive his abundant life.

This kind of thinking is rampant in the American Church. Americans believe it is their *God-given* right to be happy. Consider these famous words from the Declaration of Independence:

We hold these truths to be self-evident, that all men are created equal, that they are endowed by their Creator with certain unalienable Rights, that among these are Life, Liberty and the pursuit of Happiness.

(Technically, this specifies the *pursuit* of happiness, but we often overlook that little word.)

It's no wonder, then, we Christians assume we are even *more* entitled to blessings of every kind. If happiness is a God-given right for humanity, we reason, then being a Christian must certainly *guarantee* that right for us. We start believing that God *owes* us for our faithful church attendance, our tithing and giving to missions, our volunteering, our daily devotions, our righteous lifestyles. But that's not what the Bible actually says. We've been deluded.

Abundant life in God *is* a Scriptural concept. Jesus himself, in describing his role as our Good Shepherd, said:

> *"The thief comes only to steal and kill and destroy. I came that they may have life and have it abundantly."*

> *John 10:10, ESV*

But what did Jesus mean by abundant life? Did he mean wealth (or at least financial security)? Did he mean health? Did he mean a life free from relational conflict, mental depression, or struggles in general?

It took me a long, long time to understand none of these are a guarantee for believers. In fact, the Bible tells us the *opposite* is more likely true for those who choose to walk the rocky, narrow path which leads to our Savior.

I haven't actually verified this, but I would venture to guess for every verse promising prosperity there is at least one opposite verse (if not more than one) which indicates a life lived for God is difficult. As believers, we are promised people will hate us and persecute us for the sake of Christ *(Mt. 10:16-23, Lk. 6:22-23)*. We are told we will experience troubles and trials *(Jn. 16:33, Jm. 1:2, 1 Pet. 1:6)*. We will struggle with temptations and fleshly desires

and sin *(1 Cor. 10:12-13, 1 Jn. 1:8-10)*. We'll suffer *(Phil. 1:29, 1 Pet. 5:9)*.

Maybe you look at that list and wonder as I did, *"Where is this abundant life Jesus speaks about?"* There's that entitled mentality coming through! The mentality that says, *"If I'm going to follow Christ I want to get something in return"*—as if the salvation of our souls and an eternity with our Savior is not enough! If the only thing I get from God is a clear conscience, a new identity, and eternity in heaven…it is enough!

God in his sovereignty allows hardship, trials, pain, and suffering in order to drive us to our knees. He wants us to seek his face. In addition, these trials produce his character in us. We become more and more like our heavenly Father.

Is this easy? Absolutely not! But cooperating with the Holy Spirit in this refining process is a lot more productive than being angry at God over what I perceive as his lack of action in my life. It is far better than doubting my own faith—or worse, doubting God.

Just as the characters in the books I write ultimately have no say over the circumstances of their lives or the outcome of the story, neither you nor I can make any demands on God. He does not owe us anything, nor must he do or give us anything. As Author, he has total control.

At face value that might seem scary or unfair, but in reality there is no better place we could be. God loves us and has our greatest good in mind. We can rest assured that:

> *…in all things God works for the good of those who love him, who have been called according to his purpose.*

> *Romans 8:28*

Truth from God's Word

God has given us power to defeat the Enemy both in our minds and our hearts. Take some time to read and meditate on these Scriptures:

- ❖ Job 38:1-42:6
- ❖ Psalms 119:65-72
- ❖ Mark 8:34-38
- ❖ Romans 5:1-5
- ❖ 2 Corinthians 6:4-10
- ❖ Philippians 3:7-16
- ❖ 2 Timothy 3:10-4:8
- ❖ Hebrews 12:1-11
- ❖ 1 Peter 5:6

Lie Number Twenty-three: If something goes wrong God must be punishing me.

"I'm really sorry. I'm still not getting a heartbeat. I'm going to send you over to the hospital for an ultrasound."

The words hit me like an unexpected left hook. I'd been through three pregnancies before, all with only minor hiccups along the way, so I had no idea how to process this information. Granted, there had been no heartbeat at the ten-week checkup when one is often detected, but the nurse-midwife had told me not to worry: "Even with advanced technology, sometimes a baby's heartbeat isn't heard until around week twelve." So although I hadn't liked the wait, I had convinced myself nothing was wrong. Maybe this baby was positioned differently.

But as I sat alone in the imaging waiting room, watching for my husband's arrival, my hope wilted like a picked flower sitting in the hot sun. By the time my sonogram was done, we knew something was terribly wrong, even though the ultrasound technician had given us no information. She hadn't

needed to. It was written on her face. The short follow-up visit with the midwife confirmed our worst fears.

"I'm sorry. This pregnancy isn't viable. Your body will probably begin spontaneous abortion within the week."

That was it. As if all our excitement and joy at welcoming another beautiful life into our family was not crashing down around us. As if this were not a *child* we were talking about—*our* child. We drove numbly to my friend's house to pick up our other children then tried in the briefest of terms to explain what was going on: "Something's wrong and our baby is sick. He or she may die." Neither of us could yet utter the words as fact.

When we got home, I shut myself up in our bedroom and poured out my heart to God—all my shock, all my grief, all my anger. Later, after the children were in bed, my husband and I held each other and sobbed gut-wrenching sobs until we could sob no more. Then we called our parents to give them the news and cried all over again.

I went to bed thirsty and with a pounding headache, but I couldn't sleep. Something was stirring in me, and I wasn't sure I liked it. It was just a thought at first which turned into the hope that our baby would yet live. And it wasn't merely the wishful thinking of a heart-broken mother. This was a message whispered quietly to my soul: "Trust Me. Believe."

Let me pause right here to say I am not a person of great faith. My faith has experienced enough battering rams through the years that it is shaky at best. Not that I don't believe there is a God—I do. Nor do I doubt my faith in Jesus' death and resurrection for my salvation. But the kind of faith that moves mountains? Nope. I don't think my faith would move even an anthill most of the time. So this idea to believe God for the life of our child was totally uncharacteristic of me (or my husband, for that matter).

Still, I was convinced it was what we were supposed to do, though I kept this thought to myself for a day or two.

Finally, tentatively, I mentioned to my husband that I really felt God wanted us to believe for a miracle. I was shocked when he agreed. He'd come to the same conclusion himself. That convinced me. And the tiny flicker of hope which had been trying to emerge flared up.

I began calling everyone I knew, asking them to pray. And the more people I called, the more my hope and my faith grew. Person after person gave me affirmation. Some even felt like they had heard from God as well.

I could still barely understand this new position I was standing in, but it was clearly supernatural, for there was no way I could have conjured up this kind of faith and courage and hope on my own. Emboldened, I even told people if this baby were a girl, her name would be Miracle Faith. (I was still working on a boy's name, but I was determined that it, too, would be a testament to God's miraculous work.)

And God did seem to be working. The spontaneous abortion which was supposed to occur...didn't. In fact, my hormones kept climbing, following the same trajectory they would have with a normal pregnancy. My nurse-midwife was concerned and suggested I undergo a D&C. Apparently, in the rare cases where the body doesn't reject an expired fetus, sepsis (a poisoning of the blood) can set in. If this goes undetected it means death for the mother. She wanted to take no chances, but we were adamant that unless my body rejected this baby, we were keeping it.

That decision, though bold, was easy to make at the time. But two months later it was not so easy. I had started the pregnancy with horrific morning sickness (something I'd never really experienced before) and this continued. I was physically exhausted. I was tired of going into the doctor every three days to have my blood tested in order to catch the sepsis before it set in. And I was spiritually and emotionally spent. I still believed God could (and would) perform the miracle he had

asked us to pray and trust him for, but I wished he'd hurry up and do it because I was barely hanging on.

Finally, almost seven months into this pregnancy, I could go no further. On December 13th I prayed, "God, if you're going to perform this miracle, would you please do it before Christmas; otherwise I need released from this. I'm only human, and I can't do this anymore. Please, God, please."

That afternoon I went into the lab for more blood testing. Up to that point my pregnancy hormones had been consistent with a normal pregnancy, but that day they dipped slightly. Not much, but enough. I called my nurse midwife who told me to come in the following morning for another ultrasound.

On Tuesday, December 14 I went in for my appointment still hoping that maybe, just maybe the images would show a fluttering little life in there. It was not to be. My midwife took one look at my results and hurriedly consulted an OB-GYN. He concurred. I was on the verge of hemorrhaging and needed immediate surgery. A couple of hours later I was being hooked up to an IV and told to count backwards from 100.

The shock and grief of losing a baby was nothing compared to the devastating effect this had on my spirit. I was confused and angry. I couldn't understand why God hadn't performed the miracle, especially when he'd been the one who told us to believe for it. I'd done everything he'd asked me to do, but God had turned around and slapped me in the face. At least that's how it felt.

For days I struggled with the temptation to hate God and walk away from the faith. But my entire life had been built on this belief. Who was I without it? I echoed Peter's words,

"Lord, to whom would we go? You have the words of eternal life. We believe and know that You are the Holy One of God."

John 6:68-69

But I struggled with feeling like God was mean—like he'd lied to me.

Still, I knew God *isn't* mean and *doesn't* lie, so I decided it must have been something I'd done wrong. In an effort to reconcile what had happened, I chose to believe my faith hadn't been enough, and God was unable to work the miracle because I had fallen short. I assumed God was teaching me a lesson by letting our baby die.

It took years before I could believe Robin's death was not my fault—God's punishment for my lack of faith. It took even longer for me to believe God is good. Sometimes I still struggle to believe this.

I don't know why God didn't bring life back to our baby. There are a million maybe's and what-if's. But I have come to believe that God is not capricious. He does not take pleasure in inflicting pain. And though he will one day punish those who have rejected him, God does not *punish* his children (*1 Thess. 5:9*). When he needs to correct us and redirect us, he *disciplines* us.

> *God does not punish his children*

There is a big difference between punishment and discipline. Punishment comes from the Latin word punire—punish—which means to take vengeance for or to cause pain for an offense. Discipline, on the other hand, comes from the Latin word discipulus—pupil—the same root word as disciple. Jesus took the punishment so we don't have to. Instead, we receive God's wise discipline.

God uses our pain and suffering to disciple us, to bring us into conformity with his Spirit, to make us more like him. I don't know why Robin is in heaven with God and not here on earth with us, but I do know God used that ordeal to continue to develop his character in me. With this I will chose to be content.

Truth from God's Word

God has given us power to defeat the Enemy both in our minds and our hearts. Take some time to read and meditate on these Scriptures:

- ❖ Psalms 119:71-77
- ❖ Psalms 119: 92-93
- ❖ Lamentations 3:1-25
- ❖ John 9:1-3
- ❖ Romans 5:1-5
- ❖ Romans 8:18-28
- ❖ 2 Corinthians 4:7-18
- ❖ 1 Thessalonians 5:9-10
- ❖ James 1:2-4, 12
- ❖ 1 Peter 1:3-9
- ❖ 1 John 4:18

Lie Number Twenty-four: God doesn't really know how I feel.

After we lost our baby Robin, I gave up on God.

From the time I first put my trust in Jesus as my Savior at age four until the loss of our child, I enjoyed a tender relationship with God. Despite the pain of rejection as a child and my rebellion as a teenager, I still saw God as a loving Father. I imagined him with giant arms which held me tight and a giant lap into which I crawled to escape the cares of this world—He was a great big Daddy to me, and I loved him! I related to Jesus and the Holy Spirit in equally tender ways. But Robin's death changed all that. What I felt as utter betrayal was too much for me to maintain the sweet relationship I'd had with the Trinity. My relationship with my God was broken.

Initially I wrestled with whether to even continue as a believer. In my anger and hurt I no longer knew how to relate

to God—or even if I wanted to relate to him at all. But my whole life had been built on my belief in God and my love for my Savior. I couldn't imagine denying everything my life was based on. Something inside me knew eventually those intense feelings would subside; eventually I would come to terms with God and be reconciled to him. Furthermore, I had three sets of little eyes watching my life, looking up to me as their role model.

Because I knew someday I would put all this behind me, I didn't want my children to see me abandon the faith, even for a little while. So I went through the motions, doing what a "good" Christian should. I went to church, attended small group, read my kids Bible stories, and said bedtime prayers. But I had no confidence in God or in my ability to please him. God might be there. He might have a plan. He might in his sovereignty even be using everything for my good. But he couldn't possibly know how I felt. Because if he was *really* a loving God, he'd never put his child through what I was going through.

Of all the lies I've included in this book, this is by far the hardest for me to refute, because I have no *tangible* way to prove God actually understands what we're going through. The closest I can get is the life of Jesus himself—which should be very convincing, considering the hardships, betrayal, and suffering he experienced!

But if you are anything like me, you'll understand when I tell you I can be very jaded and snarky in my own pain. I've been known to say to Jesus, *"Yes, but you didn't suffer this."* Such a mindset is challenging. It requires a good dose of faith along with a sincere effort to renew our minds. The Bible is full of examples and promises that God does, indeed, understand what we're going through. We just need to believe it!

Imagine, if you will, a mother who years ago lost one of her seven children in a tragic event—a drowning at summer camp, maybe. Time passes then tragedy strikes in the life of

one of her friends or co-workers. She, too, experiences the loss of a child—her only child—to suicide. The older woman reaches out to the younger, seeking to comfort her; she knows the anguish of losing a child. But imagine the younger woman lashing out in anger: "How could you possibly know what I'm going through? Your child died in an accident, but mine chose to leave this world! And you've still got six beautiful children; I have none." Would she be right? Technically. But the older woman can empathize far more than the younger one realizes.

Our relationship with God is a little like this. God the Father lost his only Son—sacrificed him willingly for those who didn't love him. And Jesus suffered incredibly—poverty, hunger, temptation, weariness, misunderstanding, persecution, exploitation, betrayal, abandonment, torture, and finally death. Is this list exhaustive to the plight of humanity? No. But there is a lot there to generate empathy.

In addition, we could go a step further and say Jesus took on *all* the sin and pain of the world while hanging on the cross. In which case one could argue he *has* gone through what I'm going through, what you're going through—He bore *my* pain and *your* pain. We often quote scriptures about sharing in the sufferings of Christ, but the reverse could be said. In some inexplicable and mystical way Christ shared in *our* sufferings by taking them upon himself in his death.

There is no way I can look my Savior in the face and tell him he doesn't understand my pain. He does. You and I may not like the current chapter he's writing in our stories, but we can't accuse him of writing something he knows nothing about. He's experienced this dark chapter with us, and he will see us through to the satisfying conclusion at the end of the book.

Truth from God's Word

God has given us power to defeat the Enemy both in our minds and our hearts. Take some time to read and meditate on these Scriptures:

- ❖ Psalms 103:8-18
- ❖ Psalms 139:1-18
- ❖ Isaiah 40
- ❖ Isaiah 49:14-16
- ❖ Isaiah 54:4-17
- ❖ Jeremiah 29:11-14
- ❖ Romans 8:26-39
- ❖ Hebrews 2:10-18
- ❖ Hebrews 4:15-16
- ❖ Hebrews 12:1-4

Lie Number Twenty-five: God is not enough for me.

Ultimately, every other lie boils down to this one. In every failure, in every heartache, in every moment of depression and hopelessness which led to my believing a lie about myself and my identity or about others and the world around me, I failed to understand *God* is truly what I need. I sought acceptance, love, success, happiness, contentment, and identity in something other than my Lord and my Savior.

But nothing outside of God can meet my needs. Nothing outside of God can make me happy. Nothing outside of God can satisfy. Let me repeat this: absolutely nothing and no one can truly satisfy any longing of my soul....or yours. This lie is the one that is so hard to get past.

The soil around our house is full of clay, and we live in an arid climate. Without rain the sun beats down on

that clay-soil, baking it rock hard. When we moved into our house, I wanted my husband to sink our trampoline into the ground. I thought it would be a bit safer for the kids and would look aesthetically pleasing. He groaned but agreed to try.

I remember the Saturday he attempted this feat. The sky was blue, the sun was shining, and a pleasant breeze promised to cool him. The children skipped around excitedly, wanting to be near him as he worked. Right before lunchtime he appeared at the screen door, dripping in sweat and out of breath.

"If you want that trampoline sunk, you can dig it yourself!"

"Why? Is it that hard?" I asked, stepping outside to survey his progress.

He'd managed to chip away a two or three foot section all of one foot deep.

"Hard? That ground might as well be bedrock! I don't even think a CAT (a small backhoe) could dig your hole in that dirt."

The walls of my heart are like the hard-packed clay in my backyard. I can tell my brain over and over again God is all I need, but the truth of those words don't seem to sink into my heart, and I go looking for love, happiness, fulfillment, and identity in all the wrong places.

The Christian life has been likened to a journey, and it's a good metaphor. We have to take that first step onto the path (belief), and we have to keep going (faith). Sometimes we encounter distractions, obstacles, even dead ends. We have to ignore the distractions…but sometimes we don't; which means we have to rouse ourselves and find the gumption to start moving again. We have to step over or around the obstacles… but sometimes we trip; which means we have to pick ourselves up and brush ourselves off. And when we realize we've hit a dead end, we have to turn around, retrace our steps, and get back on the path.

The journey is hard—no one said it would be easy! In fact, Jesus said,

"For the gate is narrow and the way is hard that leads to life, and those who find it are few."

Matthew 7:14, ESV

Every epic story is a journey fraught with struggles, hardships, and even failure…but there is also love, beauty, and triumph. And every story begins with a storyteller. There is *no* story, in fact, unless someone tells it.

Your story (and mine) is the work of the Master Storyteller. He's the one who had the idea for your story in the first place. He's the one who chose the setting and the characters. He's the one who decided what kind of story it would be—the theme and genre. He outlined the plot, from start to finish, and he's been writing it all along.

The Author of your story is the only security you need to make it through that hero's journey and see it safely home in the end. Do not doubt this. Do not fight it. Instead, strive to lay down the pen and let God be the all in all that he is.

> *God is everything you need.*

Where you need to repent, repent. Where you need to take captive the lies, take them captive. Where you need to renew your mind, renew it.

God is *everything* you need. Let him be the Author. Let him write his Masterpiece.

Truth from God's Word

God has given us power to defeat the Enemy both in our minds and our hearts. Take some time to read and meditate on these Scriptures:

- ❖ Job 28:12-28
- ❖ Psalms 16:2, 5-11
- ❖ Psalms 25
- ❖ Psalms 34
- ❖ Psalms 62:5-8
- ❖ Psalms 63:1-8
- ❖ Psalms 73
- ❖ Psalms 145:14-21
- ❖ John 15:1-11
- ❖ Ephesians 3:14-21
- ❖ Philippians 3:7-14, 20-21
- ❖ 2 Timothy 4:16-18
- ❖ Hebrews 10:19-23
- ❖ 1 Peter 2:1-5
- ❖ 2 Peter 2:4-9
- ❖ Jude 1:24-25

The Story's Resolution
(A Conclusion)

Letting God write my story requires
surrender but results in peace and hope.

God is a Master storyteller—he knows how to write a Masterpiece every single time. Your life's story is no exception.

By now I hope you're convinced of God's desire to use your story regardless of the smudges on the pages of your life. I've told you story after story from my own life in the hope that you'll understand you are not alone. We all struggle with doubt, disappointment, failure, and self-limiting beliefs. But this doesn't mean our stories are relegated to remain rough drafts. You can be

...confident of this, that he who began a good work in you
will carry it on to completion until the day of Christ Jesus.

Philippians 1:6

The Author of our stories is committed to editing and polishing them until *his* story is told in and through each of us! In fact, the smudges often make our stories *more* usable.

One of my mentors, former pastor and bestselling author, Kary Oberbrunner often says, *"The area of your deepest wound will become the area of your greatest impact."*

It is precisely the pain, suffering, struggles, and failures which make our stories—and the message of hope we have in Jesus Christ—relevant to the world at large. Instead of agreeing with what the Antagonist has to say about these hardships and writing dead end plotlines, we need to surrender to the Author's storyline. We were never intended to supply the ink, only the paper.

So how do we give the pen back to God? First, we have to admit we've been trying to write our own stories. If you've never realized this before, if you have never surrendered your life to God, now is the time to do it! It's simple:

- ✓ Admit you have sinned (done things outside of God's design) and tried to dictate your life but now recognize God wants to write your story.
- ✓ Believe and acknowledge Jesus died to pay the debt you owed for those sins—a debt you could never pay on your own because you *cannot* be good enough to please God.
- ✓ Ask God to take control of your life from here on out.

If you walked through those steps for the very first time, welcome to the family of God! I recommend you tell someone about your decision and get plugged into a group of likeminded believers. If you have already trusted in Jesus as your Savior but have been ghostwriting your story, the process to freedom is similar. Admit you've been trying to dictate your life and ask for God's forgiveness. Your heavenly Father is loving and faithful; he *will* forgive you.

Whether you are a brand new believer or have been walking with God for a long time, breaking free of the enemy's lies also requires a willingness to be vulnerable and look deeply to discover which lies you have believed. I hope this book has helped with that process, but God's Word is even more useful for this. It is a powerful tool which can reveal the lies:

> *...breaking free of the enemy's lies also requires a willingness to be vulnerable...*

*For the word of God is living and active and sharper than any two-edged sword, piercing to the division of soul and of spirit, of joints and marrow, and **discerning the thoughts and intentions of the heart.***"

Hebrews 4:12

Sometimes I have uncovered lies simply by reading the Bible. Ask the Holy Spirit to reveal truth to you as you read his Word.

You can also ask the Holy Spirit to *directly* reveal the lies to you. I do this all the time, especially when I have an ongoing negative thought or attitude but am confused about where it is coming from. For example, as I was writing this book I kept struggling with the thought that I should just quit. I couldn't understand why, since I knew God had called me to write this book. Granted, writing a book is hard work, but this doubt went beyond my typical writer's slump. I would complete a section of the book only to say, "I don't know...I don't think I can do this. Maybe I should just give up."

Finally, I asked the Holy Spirit to show me what was going on. In the quiet way he speaks to our hearts, he showed me I was afraid of looking foolish or of letting others down.

Whenever someone writes about a topic, people automatically tag the author as an expert. They assume the author has

her act together when it comes to the topic addressed in the book. But I am far from this goal! Though I understand the principles in this book, and though I have found some victory in each of these areas, overcoming the lies of the enemy is an ongoing struggle in my life, just as it is in yours. It took revelation from the Spirit to figure out what exactly was going on. Once I understood, I could address it.

Which brings me to another point: this is an ongoing process that will continue long after you've put this book down. Our Adversary has a nasty habit of recycling the lies we've struggled with. He's also ruthless—he'll use future situations to speak different lies to your mind. Overcoming the Antagonist takes a lifelong commitment, but it is worth the struggle!

The Apostle Paul urged,

Do not conform to the pattern of this world, but be transformed by the renewing of your mind...

Romans 12:2a

It is the Word of God in all its forms—the written word of Scripture (logos), the living Word (Jesus), and the personal word spoken to each individual by the Holy Spirit (rhema)—which will transform your thinking. Steep yourself in what God has to say. Don't let those lies bounce wildly around in your mind, ricocheting off your own thoughts and God's truth. Be forceful with them! Take them captive.

Did you know you can do this? It's one form of spiritual warfare the Father has given us to use against our enemy.

For though we walk in the flesh, we are not waging war according to the flesh. For the weapons of our warfare are not of the flesh but have divine power to destroy strong-holds. We destroy arguments and every lofty opinion raised

against the knowledge of God, and take every thought captive to obey Christ.

2 Corinthians 10:3-5

Remember, the Antagonist of your story is a *spiritual* enemy, and the lies he seeks to weave into your story are arguments and lofty opinions against God. Furthermore, if you've believed those lies for a long time, it's likely they've become strongholds in your life. Strongholds are hard to tear down; but don't lose heart! God has told us how—destroy the arguments (lies) and take those thoughts captive to the obedience of Christ.

How does one do that? For me, I literally speak the words aloud. "No Satan," I say, "I take that thought (and I restate it) captive to the obedience of Christ Jesus. I will not believe it. I will not dwell on it or even think it. Holy Spirit, I give this thought over to you to take away into captivity right now." Then I replace that lie with truth. That's where God's written Word comes in.

The written Word has power. Even Jesus defeated the devil by the written Word of God *(Mt. 4:1-11)*. It is our weapon, a sword which cuts the lies down.

Take [up]...the sword of the Spirit, which is the word of God.

Ephesians 6:17

This is why being familiar with and even memorizing Bible passages is so valuable. Knowing Scripture is like having a sword at the ready to parry each thrust of the enemy. When you take those insidious thoughts captive, replace them with the truth of Scripture!

"But," you might say, *"what if I've done all this and still struggle with the lie?"*

Sometimes the destructive thought patterns become so engrained repeating Bible verses has little effect. Our brains may know the truth, but our hearts refuse to believe it. This is particularly true if we have suffered trauma.

One of the pastors at our church came up with the following analogy that represents this perfectly. Imagine your heart has a call center with operators answering your calls for advice based on your previous experiences.[v] If, for example, you experienced betrayal in a relationship, the operator on the "relationship" phone line now gives you advice based on that one traumatic experience. "Be wary!" she says. "Relationships cause pain. You can't trust anyone!"

Because of this ongoing advice, you'll probably struggle with relationships for the rest of your life. You can tell yourself over and over again that you are a child of God, loved and accepted and secure, but unless you can get a new operator on the line who will speak truth to you, your heart will not believe what your mind is telling it. Your heart will see it as a matter of self-preservation.

But what if you could somehow get Jesus (the living Word) on the line and ask him what *he* thinks about that previous situation? Surely then you could experience freedom from both the trauma and the subsequent lie!

The beautiful thing is, you *can* get Jesus on the line through a powerful process called transformational prayer. This is a method of prayer developed by Dr. Ed Smith, wherein people ask Jesus to tell them or show them what he wants them to know about a past situation or relationship. It is as easy as saying, *"Jesus, what do you want me to know about this?"* and then listening for his answer.[vi]

Most people who have experienced freedom using this method of prayer say the answer they receive is very simple—one word or sentence, perhaps a visual picture or simply

a feeling. In any case, when *Jesus* speaks, the stronghold is broken. Your heart is now set free to hear the truth.

Our Antagonist is crafty. Do not let him win! Take your thoughts captive to the obedience of Jesus and replace them with the Word of God—logos, living, and rhema. Whenever Satan tries to sneak them back into your story, repeat the process again! This is hard work, and it takes time. Transformation usually doesn't happen overnight. But this uphill struggle is worth it. It means your story becomes a Masterpiece written by God for others to read, a story that points back to the Author and gives him glory.

There may be smudges on the pages, but yours is a beautiful story of belonging and identity—a story of love, mercy, forgiveness, acceptance, and hope.

Truth from God's Word

God has given us power to defeat the Enemy both in our minds and in our hearts. Take some time to read and meditate on these Scriptures:

- ❖ Isaiah 27:2-3
- ❖ John 8:34-36
- ❖ John 10:9-10
- ❖ 2 Corinthians 10:3-5
- ❖ Ephesians 4:17-24
- ❖ Ephesians 6:10-18
- ❖ 1 Peter 5:8-11
- ❖ 1 John 4:1-6
- ❖ 1 John 5:1-5
- ❖ Revelation 2:7, 11, 17, 26-29

Endnotes

i Serva, Christine. "What Is Personal Identity?-
Definition, Philosophy, & Development." *Study.
com*, 15 May 2015, study.com/academy/lesson/
what-is-personal-identity-definition-philosophy-
development.html.

ii Chowdhury, Roy Maduleena. "The Neuroscience
of Gratitude and How It Affects Anxiety & Grief."
PositivePsychology.com, 1 Sept. 2020, positivepsychology.
com/neuroscience-of-gratitude/.

Emmons Robert A; McCullough, Michael E. "Counting
Blessings versus Burdens: an Experimental Investigation
of Gratitude and Subjective Well-Being in Daily
Life." *Journal of Personality and Social Psychology*, U.S.
National Library of Medicine, Feb. 2003, pubmed.ncbi.
nlm.nih.gov/12585811/.

Harvard Health Publishing. "Giving Thanks Can
Make You Happier." *Harvard Health*, Harvard Health
Publishing, www.health.harvard.edu/healthbeat/
giving-thanks-can-make-you-happier.

iii Benge, Janet, and Jeff Benge. Christian Heroes: Then &
Now series. YWAM Publishing.

iv Laura Story. *Blessings*, INO Records, 12 Apr. 2011.

v Meyer, John. Being Discipled by God. 2019, Fort Collins, Summitview Church.

vi Smith, Ed, and Joshua Smith on February 24. "Preparing for the Journey: Introduction." *Transformation Prayer Ministry*, 2 Mar. 2020, www.transformationprayer.org/ preparing-journey-introduction/.

Acknowledgements

Books are not born in a vacuum. They take the input and talent of so many people, not just the author.

I knew this before—in theory—but writing *Smudged Pages* solidified this truth for me! So many people contributed. I want to acknowledge their time and expertise and thank them publicly.

First, the biggest thank you to God for putting the idea for this book and this ministry in my heart. I am endeavoring to steward well the "talent" I've been given.

Second, thank you to Heidi for believing in me, encouraging me, and working tirelessly on the book cover, website, and a million other little details I'm sure I've forgotten. You are truly my right hand gal!

Third, a thank you to my parents for contributing significantly so I could get the training I needed. And a thank you to my husband and kids for dealing with this all-consuming project. You'll see me again someday...

Finally, a thank you to Kary Oberbrunner and his amazing team, especially Chris McClure, Lisa Moser, Linda Outka, Daphne Smith, Niccie Kliegl, and Janine Lansing for providing training and encouragement. You have literally transformed my life! I am grateful to God for you.

Next Steps

So what now? You've read the book. Hopefully you've identified some of the Antagonist's lies in your own life. Maybe you've found some freedom already. If so, praise God! But maybe you could use a little help, a little extra encouragement to work through everything you've just taken in. Or maybe you'd like to delve into this process with a group of friends.

If that's you, I have created both a companion guide (and optional accompanying online course) and a devotional to go along with *Smudged Pages: Letting Go of the Lies and Letting God Write Your Story*. Transformation doesn't have to be theoretical; you *can* release that tight grip on the pen and let God write the Masterpiece he has planned!

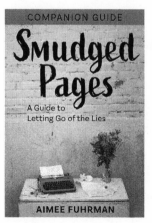

The Smudged Pages Companion: A Guide to Letting Go of the Lies, is less a step-by-step process and more like a friend sharing tips to help you tackle the lies head on and engage with God's truth in a way that brings freedom. This companion guide can be completed either independently or with a group. Through Bible reading and thought provoking questions, the workbook examines each of the 5 major categories of lies found in the *Smudged Pages* book. With expanded content and additional scriptures, these overarching lies are exposed for what they

are—spiritual strongholds. *The Smudged Pages Companion* challenges you to take the next step in your spiritual journey by pressing into the Holy Spirit and letting him reveal what's been hiding in the shadows.

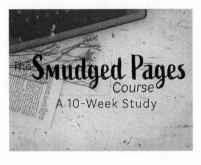

For those who want even more help with the process, I've created an online course. It's not enough to recognize you've bought into the enemy's lies. It's not enough to recognize the truth. To see any real change you have to be willing to do the hard work of transformation. Transformation comes not only through *knowing* the truth but by *applying* it. Breaking free from the lies that have bound you involves:

- Identifying the lies
- Understanding their impact
- Repenting and asking for forgiveness where needed
- Identifying truth to counter the lies
- Internalizing that truth
- Implementing changes

Each online lesson dovetails with the content found in *The Smudged Pages Companion,* but additional information and helps are available, as is optional small group or one-on-one coaching. This course is for those who want to dig deeply in order to root out the lies and find freedom.

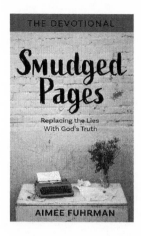

The Smudged Pages Devotional: Replacing the Lies with God's Truth, is a 30-day conversation with the Author of your story. In short, easy-to-read daily reflections, it examines more closely one or more truths found in God's Word to combat each of the 25 lies addressed in *Smudged Pages: Letting Go of the Lies and Letting God Write Your Story*. Like a refreshing summer rain that washes away the grime and fosters new growth, this devotional dives into relevant scriptures to bathe your mind with God's truth, bringing healing and renewal.

For more information or to order one of these resources, go to **www.SmudgedPages.net**.

Both the companion guide and the devotional are also available wherever books are sold.

About the Author

Aimee Fuhrman is a recovering perfectionist. For years the lie of perfectionism held her captive. But God rescued her and set her on the path to believing His grace is truly sufficient. Now through her ministry Smudged Pages she seeks to encourage other women to break free from the lies which bind them and to find their God-given identity.

STAY CONNECTED!

Instagram @smudged_pages

Facebook @smudgedpages

Twitter @ae_fuhrman

smudged PAGES

We all have smudges on the pages of our lives—those messy bits that make us less than perfect. Too many women struggle to achieve a picture perfect life and then sink in shame and despair when they fail to meet that standard. Smudged Pages seeks to help mothers break free from this cycle of false guilt and to find their identity in Jesus so they can live from a place of grace, peace, and rest.

Our ministry offers:

- A weekly blog
- Facebook groups
- Training videos
- Book lists and reviews
- Recipes—gluten-free and allergy friendly!
- Books and homeschooling curriculum
- Hands-on learning boxes

In addition, Aimee is available for speaking engagements and coaching sessions.

For more information visit: **www.SmudgedPages.net**

CAN THE TRUTH OF HUMANITY BE RECLAIMED?

When WW3 brings humanity to the brink of extinction, desperate measures are enacted to ensure that nothing like this will ever occur again. A global government controls the world's population through forced supplements and genetic modifications.

But some are immune to this treatment...

Considered a threat to society, they are labeled Deviants and are interned in relocation campuses. Yet one Deviant, locked away from humanity, uncovers evidence that persuades her the entire population is living a lie.

Now can she convince anyone else before she is silenced?

(YA Christian Dystopian series The Resistance book 1)

A POWERFUL ABILITY HAS SURFACED...
BUT SHOULD IT BE REPLICATED?

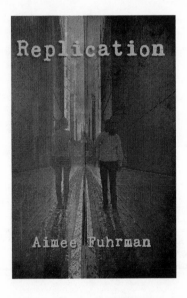

Something is wrong—Colette Vegas can feel it.

When a brain aneurysm and stroke rob her of her memory, Colette undergoes an experimental procedure. All seems to go well. But then Colette begins experiencing memories that aren't her own....Someone else is inside her head.

In seeking answers to this disturbing problem, she discovers a powerful connection with Leera Coonts, a rehabilitated Deviant. But the two of them may have stumbled across more than they've bargained for. Powerful people are interested in what they've got and will stop at nothing to replicate it.

(YA Christian Dystopian series The Resistance book 2)

TEACHING YOUR CHILD TO READ DOESN'T HAVE TO BE A TEDIOUS EXPERIENCE!

Take your child from basic phonetic decoding to confident and fluent reading using this unique program.

- Quality children's literature provides a rich reading experience
- Comprehension questions build understanding and cognitive skills
- Internet links and springboard activities enhance learning

All books are incrementally sequenced (levels 1-4). New sound blends and sight words are introduced as they occur, ensuring reading success. A reading assessment and additional reading aids are provided for the parent/teacher.

In addition, the books in this program were chosen to include:

- All major subject areas: history, geography, math, science, and art
- Every continent
- Every major people group in the US: black, Hispanic, Asian, Native American, Middle Eastern, and disabled

You and your child can enjoy the learn-to-read process!

wonderful
writing
prompts

Aimee Fuhrman

Do you have resistant writers? Are you unsure how to go about teaching writing?

THIS WRITING PROGRAM IS FOR YOU!

Focusing less on the mechanics of writing and more on developing eager writers who are able to communicate information and ideas well, WONDERFUL WRITING PROMPTS is a fun and gentle approach to both creative and informative writing.

In this program students learn:

- the style elements common to all major genres of fiction
- several popular types of poetry
- the most common forms of non-fiction writing
- Simple to follow grammar tips and a correlated reading list are included.

Combining instruction, examples, and kid-friendly writing prompts, WONDERFUL WRITING PROMTS is an easy, no-prep, tears-free program!

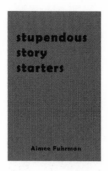

stupendous
story
starters

Aimee Fuhrman

Whether you are an aspiring author, hate writing, or fall somewhere in between— STUPENDOUS STORY STARTERS is for you!

Children and adults alike will find inspiration here for everything from school projects to personal writing development. STUPENDOUS STORY STARTERS is a unique writing tool. Use alone or in conjunction with WONDERFUL WRITING PROMPTS.

STUPENDOUS STORY STARTERS contains:

- Story Starters to over 60 stories—you get to finish them!
- Extra Inspiration prompts—to help you think through your story possibilities
- Fact Checker feature—historical details for those starters based on real life events
- Writing Hints—for those genres most find trickier to write

With over 60 Story Starters to choose from in every genre imaginable, you will be writing stupendous stories in no time!